PUB DOGS OF LONDON

PUB DOGS
OF LONDON

*Portraits of canine regulars in
the city's world famous hostelries*

FIONA FREUND & GRAHAM FULTON

**FREIGHT
BOOKS**

First published in the UK, 2015

Freight Books
49-53 Virginia Street
Glasgow, G1 1TS
www.freightbooks.co.uk

A CIP catalogue reference for this book is available from the British
Library

ISBN 978-1-910449-41-7

Typeset by Freight in Trump Gothic East & FS Clerkenwell
Printed & bound by Hussar Books, Poland

the publisher acknowledges investment from
Creative Scotland toward the publication of this book

FOREWORD

London is famous for its hostelries. From Chaucer's Southwark Tabard, where the **Canterbury Tales** begin, to Graham Swift's all-too-stationary Coach and Horses in **Last Orders,** the London public house is and always will be a fixed point in the capital's ever-changing landscape; one which is a breed apart from any other drinking establishment in the world.

The words 'London Pub' conjure up an image of gleaming brass, leather seating, pints of London Pride, Beefeater gin and tonic and the flickering lights of a fruit machine in the corner. They're also inextricably linked to the cultural heroes and villains of the city: the Kray twins, the regulars of the Queen Vic, Jeffrey Bernard and his liquid lunches, the characters from **Lock Stock and Two Smoking Barrels** and, of course **that** scene in **Withnail and I.**

One of the most essential components besides beer, is of course the pub dog, sitting patiently at its owner's feet, occasionally looking up to see who's come in. This book is a celebration of the extraordinary range of sizes, breeds and demeanors of all those four-legged regulars to be found in London's great pubs.

We're hugely indebted to Fiona Freund, a highly accomplished portrait photographer with a wealth of experience in taking portraits – and a **bona fide** Londoner herself – who took on this massive task. With skill and a great deal of patience she's brilliantly captured the unique personality of each individual pet in its natural environment, utilizing her encyclopedic knowledge of London's demi-monde as she went.

We of course offer our heartfelt thanks to all the dogs (and their owners...) who agreed to let their muzzles grace these pages. We couldn't have done it without you. Thanks also to Graham Fulton, a poet with an eye for the quirky, who has provided some occasional verse inspired by some of the pooches.

And at the back of the book you'll find a list of the excellent establishments that provide the all-important backdrop of these portraits. We salute you, landlords, for being so accommodating with your canine regulars!

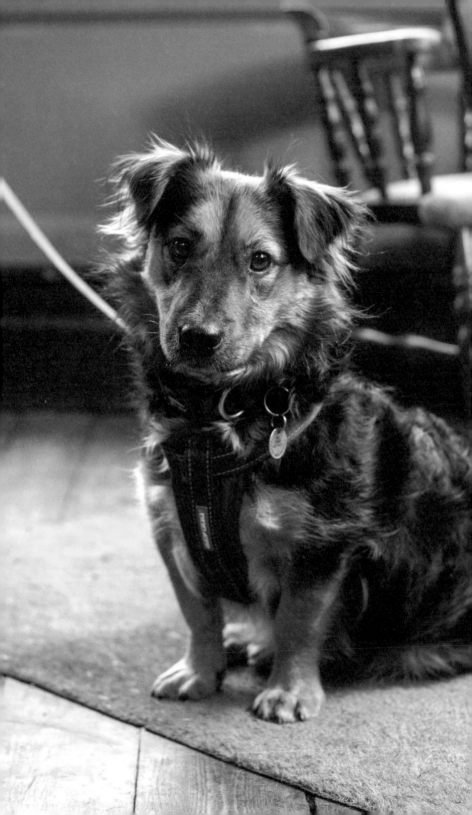

DOUGIE

ELM PARK TAVERN

Dachshund Cross

Where do they sleep?
Anywhere in the house – normally
settee in the lounge

Favourite things
Frankfurter sausages & squeaky
toys, running with his new friends
in the park

Most dislikes
Loud noises & a collar

Favourite Place
Home, Elm Park Tavern
& Brockwell Park

Favourite Drink
Water

When not in pub likes to
Play with his many toys & sleep

Likes cats or loathes cats?
Not too keen on cats

Best trick
Talking to me

Favourite toy
Vibrating dog's head

Favourite treat
Frankfurter sausages

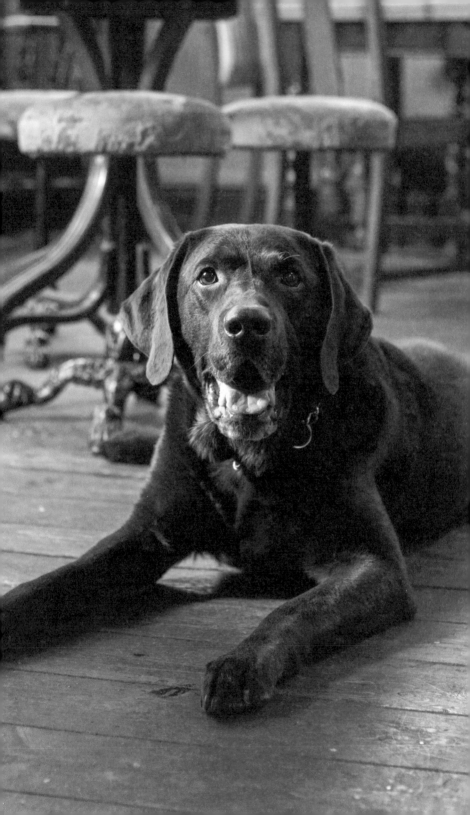

HARRY

ELM PARK TAVERN

Labrador

Where do they sleep?
With my mom of course

Favourite things
Eating, sleeping, walking & lots &
lots of cuddles

Most dislikes
Having my ears cleaned

Favourite place
Next to my mom

Favourite drink
Milk, but I'm not allowed it

When not in pub likes to
Think about going to the pub,
& when my next meal is

Likes cats or loathes cats?
Like my own, loathe anyone else's

Best trick
Rolling over & over & over

Favourite toy
Squeaky spacehopper

Favourite treat
Rawhide chews

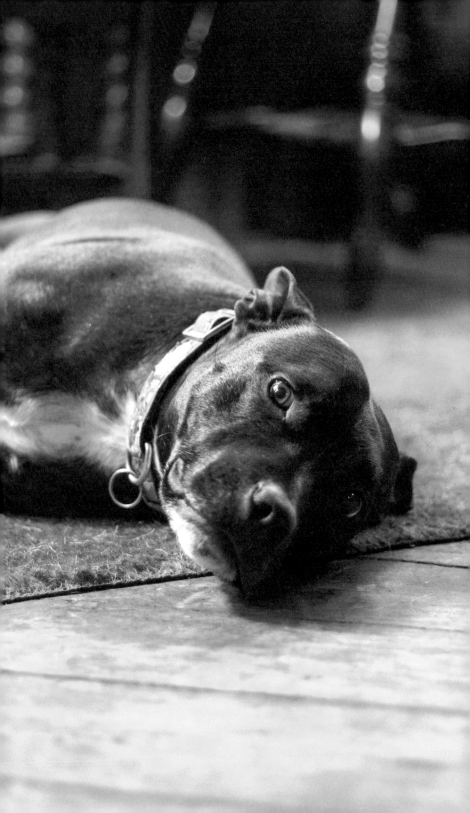

DEL BOY

ELM PARK TAVERN

Staffie

Where do they sleep?
In the living room, the sofa is king

When not in pub likes to
Run around with my sister Hada

Favourite things
Digging & chasing squirrels

Likes cats or loathes cats?
Loathe them – I'm a dog, you know?

Most dislikes
When Manolito steals my attention

Best trick
I sit & give both paws

Favourite place
Brockwell Park

Favourite toy
What ever toy Manolito likes

Favourite drink
Water

Favourite treat
Pig's ears

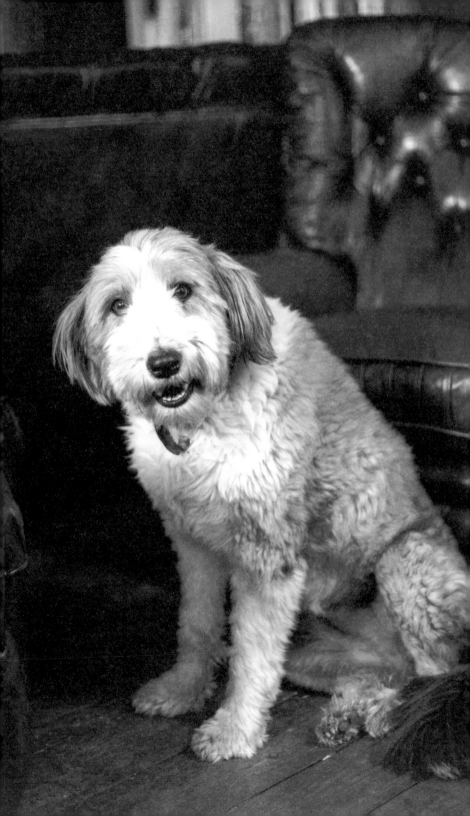

DIBLEY

ELM PARK TAVERN

Bearded Collie

Dibley's Light

I hope the world can't see me.
If I keep my head down
and hide among
the green chairs
then there's a fair chance
it won't see me.

So far, so good.
There's so much to be
afraid of in this life.

Hats, for one. Any type of hat.
Pork pie, straw boater,
fedora, bowler.
There's something about a hat
that sends a tremble
up my spine.

And walking sticks,
Staffies, skateboards, the dark.

The end of light.

The worst thing of all would be
a Staffie wearing a hat
while riding a skateboard
in the dark.
And not forgetting

anything that appears in
the wrong place,
something from somewhere else
that shouldn't be
where it is.
A cup, a shoe,
a star, a word.
My equilibrium, upside down.

We all need light

because there's so much
to love as well!
Everything has its cosmic twin!

Sleeping with my head
in a flower pot.
Cheese, geese, Mai Tais, cats.

Unless, of course, the cat
is holding a walking stick.

DIBLEY

Where do they sleep
With head in flower pot

Favourite things
Ham, balls, our cats,
seagulls & geese

Most dislikes
Staffies, hats, walking sticks,
skateboards, the dark, anything
that appears in the wrong place

Favourite place
Richmond Park

Favourite drink
Mai tai

When not in pub likes to
Watch cats

Likes cats or loathes cats
Likes cats

Best trick
Being Dibley!

Favourite toy
Howard – owner's husband

Favourite treat
Teeth cleaning chews & cheese

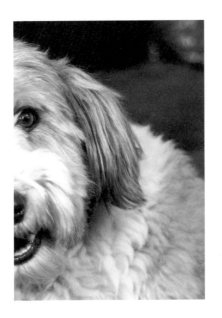

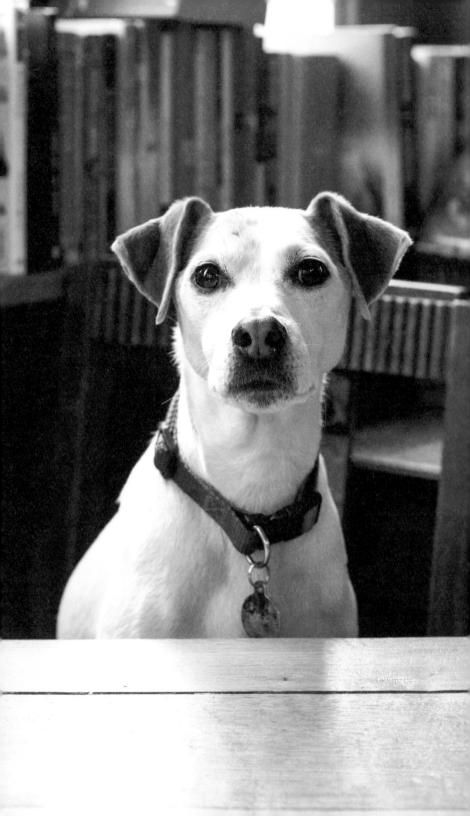

SCOOBIE 2 ELM PARK TAVERN

Parsons Jack Russell

Where do they sleep
Sofa

Favourite things
Chasing ball, running in woods,
jumping after ball in the sea

Most dislikes
Postman

Favourite place
The sea side

Favourite drink
Water

When not in pub likes to
Walk

Likes cats or loathes cats?
Isn't bothered

Best trick
Jumping up for toys

Favourite toy
Loads

Favourite treat
Biscuits

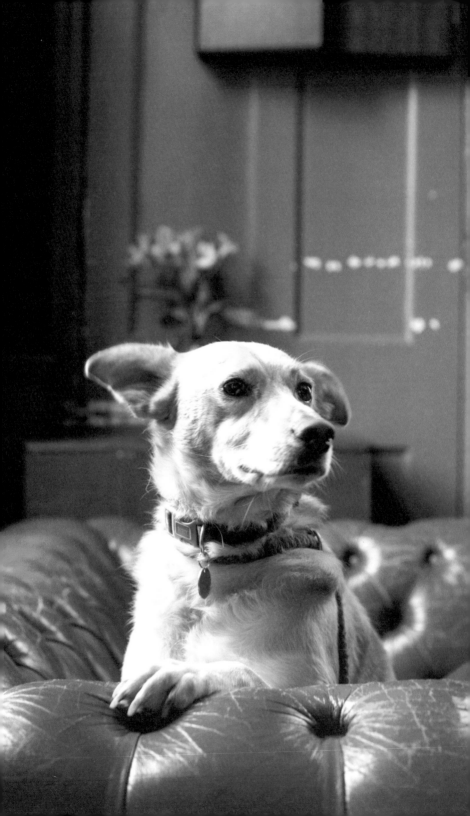

HADA

ELM PARK TAVERN

Mongrel

Hada's Hubris

Tricks? Forget it.
Toys? No way.

Don't do them, don't need them.
I'm a Rebel with four paws,
the James Dean
of the doggy world.

If I was a High One
I'd wear a red windcheater jacket
and comb my hair
way back on my head.

Roll a milk bottle
across my brow.
Say things like
You're tearing me apart!
 and
I got the bullets!

Canine cool.

I laugh at the wrinkly generation.
They've got nothing I want.
I'm going to die young and have
a beautiful corpse.

And if I ever do a high five,
or bark at smelly old High Ones
in the park,
or do Elvis impersonations,
or roll over for a tummy tickle,
or play with
a vibrating dog's head
or a rubber giraffe
then it has to have been
my own decision.
No one else's.
No compromise.

That's final.
Non-negotiable.

What did you say?

Did you say... PIG'S EARS!

GIMME GIMME
PLEASE PLEASE.
I'LL DO ANYTHING.
ANYTHING!

HADA

Where do they sleep
In my bed

When not in pub likes to
Sleep

Favourite things
Chasing squirrels with Del Boy

Likes cats or loathes cats
Loathes them with a passion

Most dislikes
Being hushed

Best trick
I don't do tricks, I'm a rebel

Favourite place
Up next to the radiator

Favourite toy
Don't do toys

Favourite drink
Water

Favourite treat
Pig's ears all the way

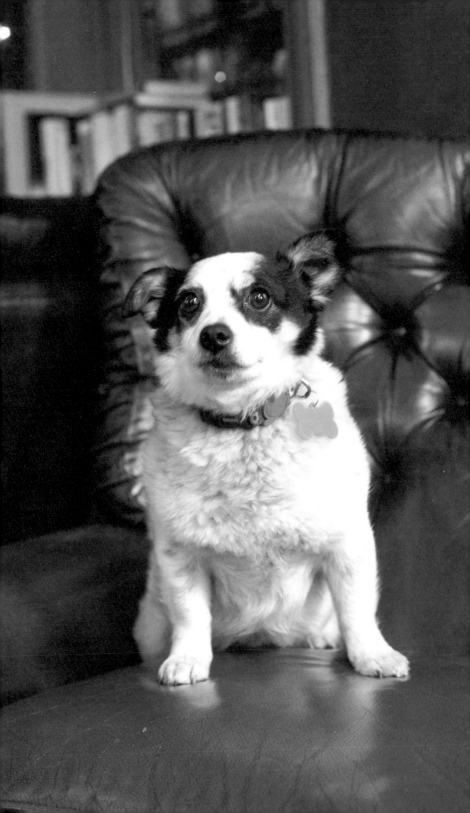

MANOLITO

ELM PARK TAVERN

Mongrel

Where do they sleep
In bed with my mum, where else?

Favourite things
Running around after little bitches

Most dislikes
Getting a bath

Favourite place
In my mum's arms

Favourite drink
Water

When not in pub likes to
Sleep & be cuddled

Likes cats or loathes cats
Loathes cats with a passion

Best trick
Bark for attention

Favourite toy
Whatever my brother Del Boy has

Favourite treat
Pig's ears

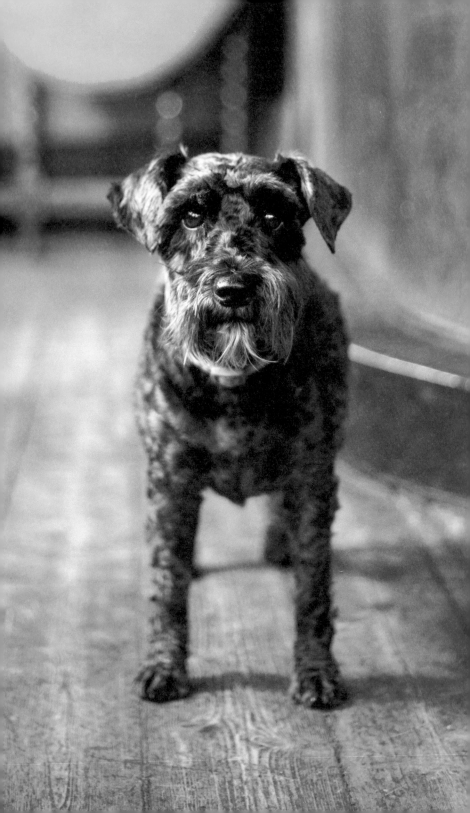

MURPHY ELM PARK TAVERN

Miniature Schnauzer

Where do they sleep
In bed with us, on the pouffe
in the snug, & anywhere else
comfy looking

Favourite things
Walks, playing tug, carrots,
edamame, cuddles, the pub &
sniffing. Oh & her bessie mates
Chalky & Danny

Most dislikes
Water & haircuts

Favourite place
Brockwell Park in the day, the Elm
Park Tavern at night

Favourite drink
The top fluffy bit of a cappucino /
Guinness

When not in pub likes to
Snooze, play & eat

Likes cats or loathes cats?
Loves. Knew a ginger tom once
& used to play with him a lot

Best trick
Making her dinner disappear in
less than 10 seconds

Favourite toy
A string of plastic sausages, a ball
on a string & Pink Pink

Favourite treat
Biscuits, carrots, edamame
& cheese

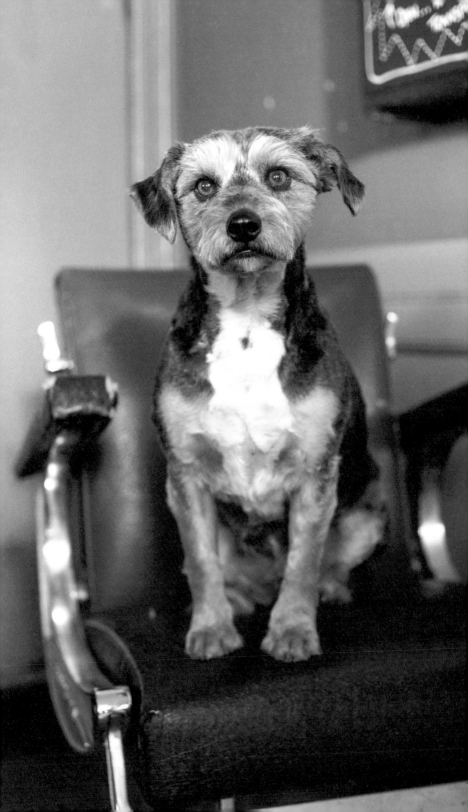

CHALKY

ELM PARK TAVERN

Terrier Cross

Where do they sleep
In bed all the time, spooning

Favourite things
Hunting, cuddles, running on the beach & swimming

Most dislikes
Cats!

Favourite place
Bed & Liz's chair

Favourite drink
H_2O

When not in pub likes to
Sit on the windowsill watching the world go by

Likes cats or loathes cats?
Loathes

Best trick
Making people fall in love with her

Favourite toy
Plastic giraffe

Favourite treat
Puddings & cheese

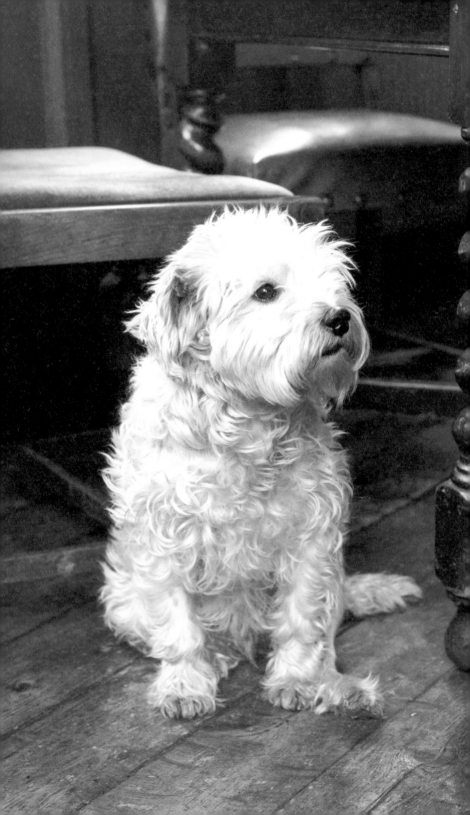

DANNY BOY ELM PARK TAVERN

Terrier Cross

Where do they sleep
In bed all the time, spooning

Favourite things
Singing like Elvis... rolling on the grass on his back with his legs up, eating beef

Most dislikes
Vets

Favourite place
Front door on guard. Swimming

Favourite drink
Water

When not in pub likes to
Chase balls & goad his sister

Likes cats or loathes cats?
Loathes

Best trick
Catching balls. Elvis impersonations

Favourite toy
Stuffed squirrel

Favourite treat
Cheese & butter

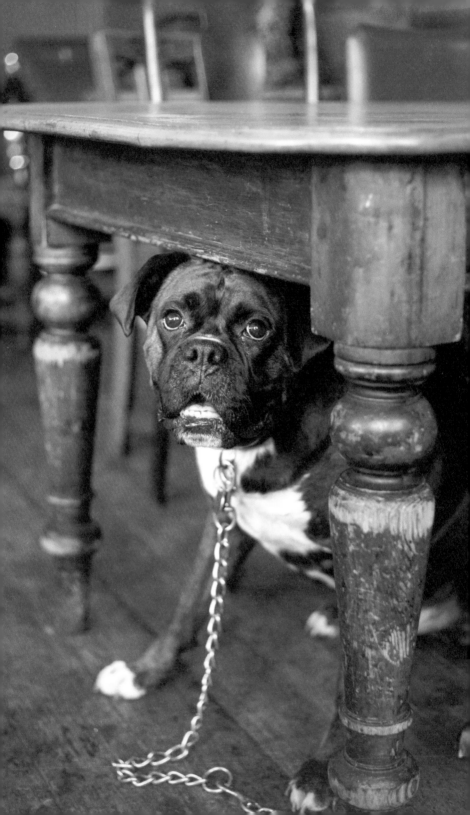

DALLAS

ELM PARK TAVERN

Boxer

Where do they sleep
In Chris, Brian or Jacob's bed –
whoever's I choose

Favourite things
Shoelaces, feet, chasing foxes,
eating, going to see the vet nurse;
ice cubes

Most dislikes
Going on a diet

Favourite place
Sitting on the sofa, looking out of
the window watching the world
go by

Favourite drink
Water with ice cubes in

When not in pub likes to
Walk around South London. Or
remove all the bed linen from beds

Likes cats or loathes cats?
Likes to chase them!

Best trick
Undoing & removing shoelaces

Favourite toy
Any new toy – I can destroy any
toy in 10 minutes

Favourite Treat
Anything edible

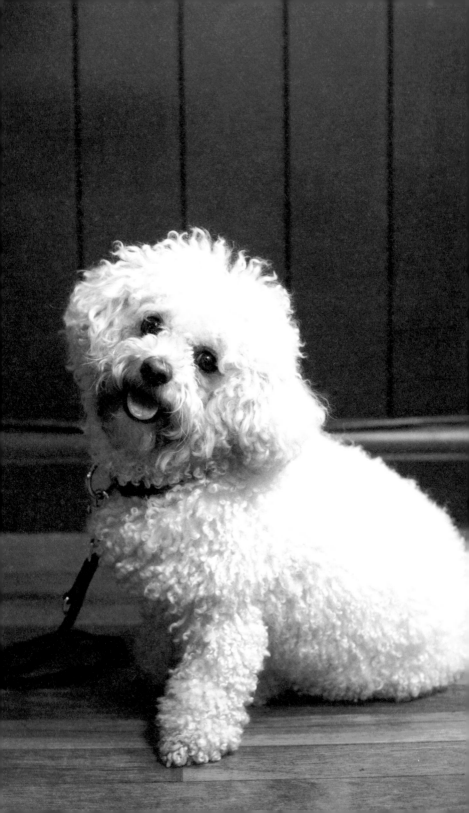

HUEY

THE MERCHANT

Bichon Frisé

Huey's Style

Right ladies, here I am!

All I have to do
is cock my head
a little bit to the side

look into your eyes
and you're mine, all mine.

I'm Warren Beatty
on four legs.
Rudolph Valentino
with a white fluffy coat.

I'm the small, silent type.
I don't use chat-up lines.
All I do is pour on the cute
then POUNCE
when you least expect it.

WOOF! WOOF!

Dachshunds, Great Danes,
Scotties and Westies,
Spaniels, Labs.

No one is safe.

There are lots
of tiny versions of me
running about all over London
wondering who their daddy is.

I'm Jude Law
with a collar and lead.
Russell Brand
with a waggly tail.

Wham, bam, thank you ma'am.

Then down The Double Dip
for a beer
with all of the lads,
a chew on my squirrel.

I'm the dog at the start,
and the end, of Alfie.
You'd think pig's ears
wouldn't melt in my mouth.

HUEY

Where do they sleep
At the front door, in my bedroom, on the sofa at the Merchant

Favourite things
Walks at Clapham Common, eating, visiting the Merchant

Dislikes
Screaming kids

Favourite place
On the window slip looking onto the street

Favourite drink
Beer!

When not in pub likes to
Play with his toys, chat up girl dogs!

Likes cats or loathes cats?
Loathes

Best trick
Giving his mobile phone number out at the pub!

Favourite toy
Fluffy squirrel

Favourite treat
Chicken & pig's ears

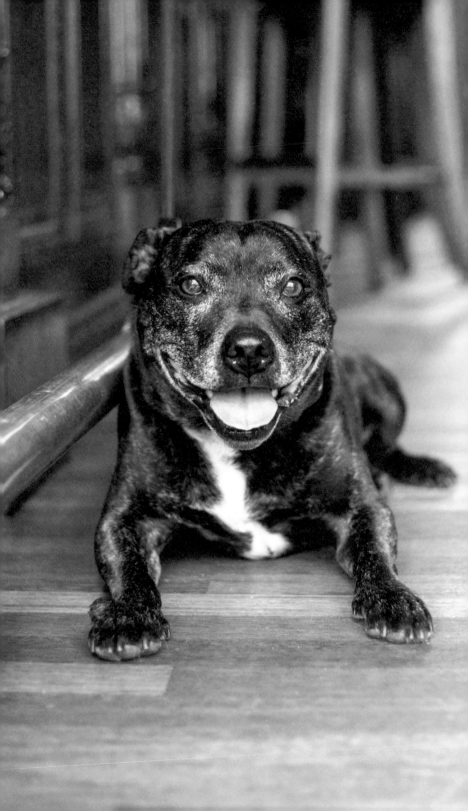

SHERMAN THE MERCHANT

Staffordshire Bull Terrier

Where do they sleep
Kitchen

When not in pub likes to
Swim

Favourite things
Food

Likes cats or loathes cats?
Loves them

Most dislikes
N / A – loves everything / everyone

Best trick
Roll over for tummy tickle

Favourite place
Bed

Favourite toy
Rawhide chew

Favourite drink
[Blank]

Favourite treat
As above

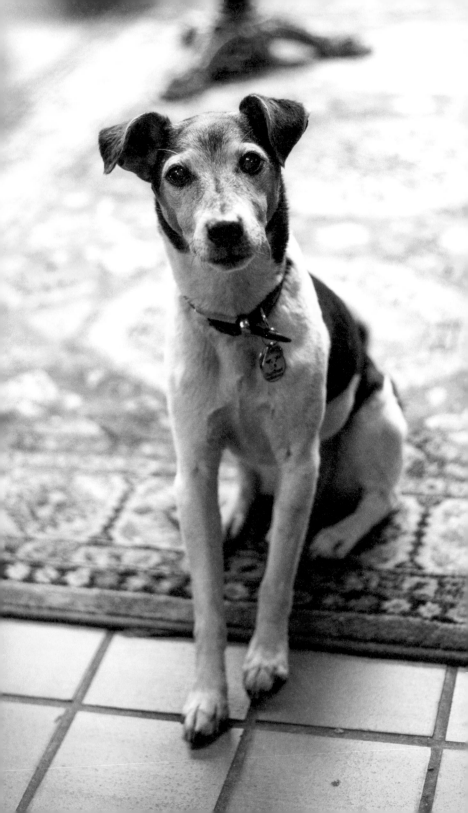

CASPER

THE MERCHANT

Fox Terrier x Whippet

Where do they sleep
In Sandra's bed

When not in pub likes to
Chase rabbits, cuddles & laps

Favourite things
Spaghetti Bolognese

Likes cats or loathes cats
Loathes

Most dislikes
Dried dog food

Best trick
Keepy uppy with a balloon

Favourite place
A cushion in the sun

Favourite toy
Toy fox

Favourite drink
Cup of tea

Favourite treat
Pork scratchings

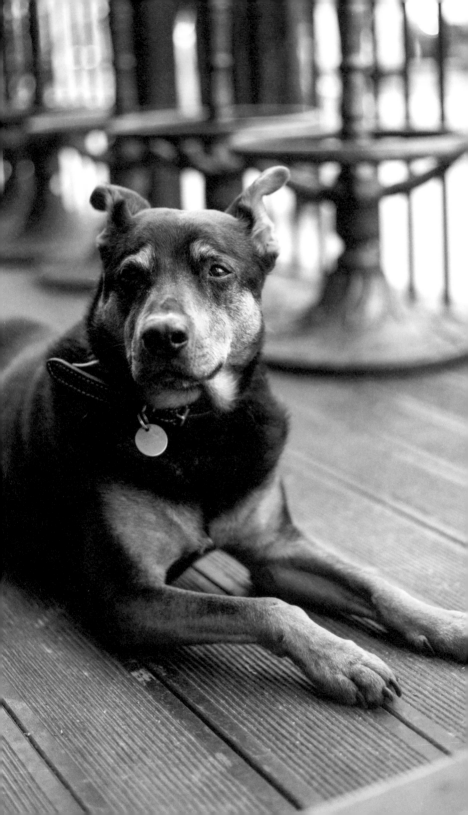

HARRY

THE MERCHANT

Mix

Where do they sleep
His bed

When not in pub likes to
Sleep & play ball

Favourite things
Balls & Chicken

Likes cats or loathes cats
Loathes cats

Most dislikes
Baths

Best trick
Give me a treat & I'll show you

Favourite place
A pub

Favourite toy
"Cat"

Favourite drink
Gravy

Favourite treat
Anything chicken flavoured

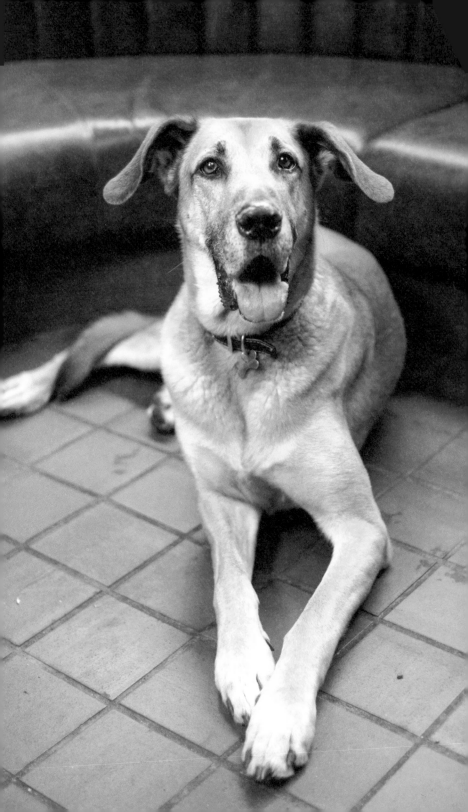

DEXTER

THE MERCHANT

Dane x Alsatian

Where do they sleep
On the sofa & the bed

Favourite things
Chasing squirrels on Clapham
Common

Most dislikes
Loud noises

Favourite place
Clapham Common

Favourite drink
Guinness

When not in pub likes to
Got to Brighton & run around on
the beach

Likes cats or loathes cats
Not fussed

Best trick
Jumping up high to reach squirrels

Favourite toy
Not into toys

Favourite treat
Chicken

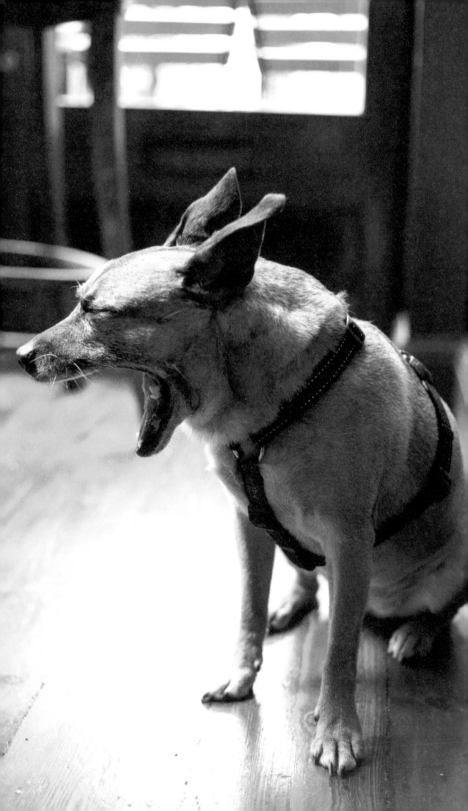

KERRIE

THE MERCHANT

Heinz 57

Kerrie's Chords

I'm Kerrie,
the Canine Karaoke Queen.
Just one look
 and you can tell
that I'm
a WILD THING!
YOU MAKE MY BARK SING!

or something like that.

Heavy metal, James Brown.
As long as it's loud.

Only drawback,
I can only remember
the first two lines of any song.

It gets a bit repetitive
for my legion of fans,
singing
I FEEL GOOD,
I KNEW THAT I WOULD NOW
over and over,
and over, again.

I FEEL GOOD,
I KNEW THAT I WOULD NOW.
I FEEL GOOD,
I KNEW THAT I WOULD NOW.

See what I mean.
They slowly start

to drift away.

I can do a great
Smoke on the Water,
a show-stopping
Jumpin' Jack Flash.
But by that time
 there's nobody left.

All I can hope is that some day
I'll be able to sing
YOU MAKE EVERYTHING
...GROOVY!

but I know for sure
it's not going
to happen.

KERRIE

Where do they sleep
In Sheena's bedroom

Favourite things
Ball

Most dislikes
Can't think of anything

Favourite place
Clapham Common

Favourite drink
Milk

When not in pub likes to
Walking on the Common

Likes cats or loathes cats
Likes cats

Best trick
Can jump to catch a ball / biscuit

Favourite toy
Tugging toy

Favourite treat
Biscuits – doggy doughnuts

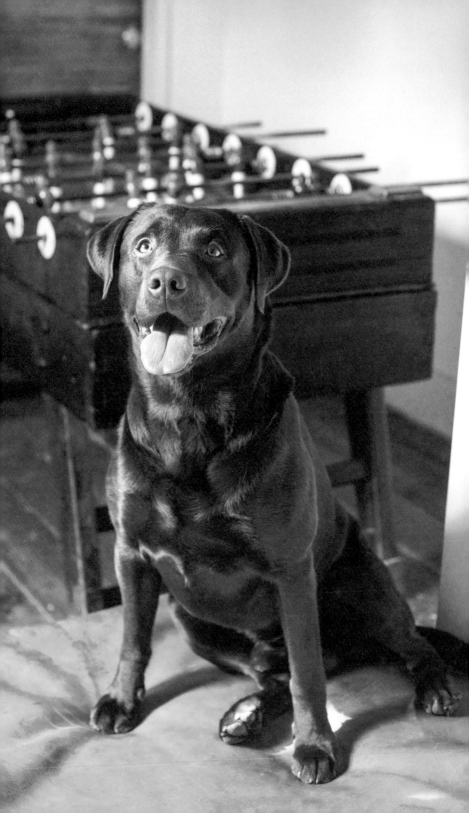

BAXTER

NO. 32 THE OLD TOWN

Labrador

Where do they sleep
On the bed given the chance!
But mainly in the spare room

Favourite things
Food, walks, sleeping,
TENNIS BALLS!! Swimming in
Battersea Park

Most dislikes
Hose pipe, flea treatment

Favourite place
The beach

Favourite drink
Chicken gravy

When not in pub likes to
Hang out with other labs

Likes cats or loathes cats
Frightened of cats. Always gives
way to a cat

Best trick
Fetches a blanket to set up on
the couch

Favourite toy
Fluffy monkey

Favourite treat
Dried liver

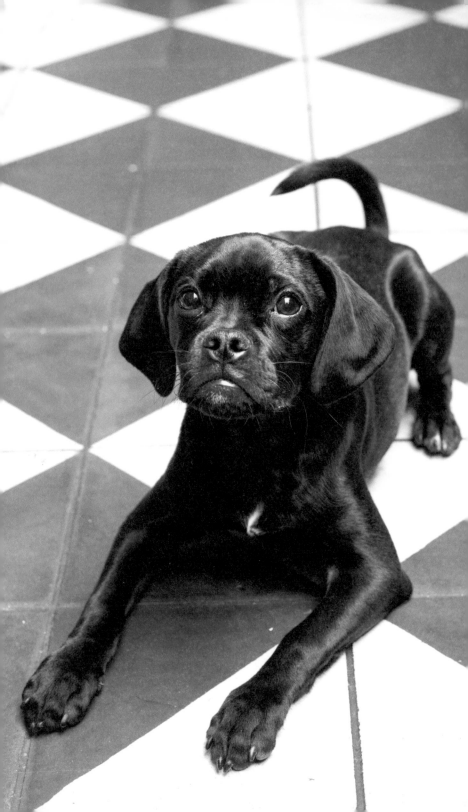

MICKY

Puggle

NO. 32 THE OLD TOWN

Where do they sleep
On my bed

Favourite things
Food

Most dislikes
Rain, cold

Favourite place
Sleeping on my lap

Favourite drink
Chilled water

When not in pub likes to
Playing with other dogs

Likes cats or loathes cats
Ambivalent

Best trick
Tapping my closed hand to get the treat

Favourite toy
Sheep cuddly toy

Favourite treat
Pig's ear chew, cheddar cheese

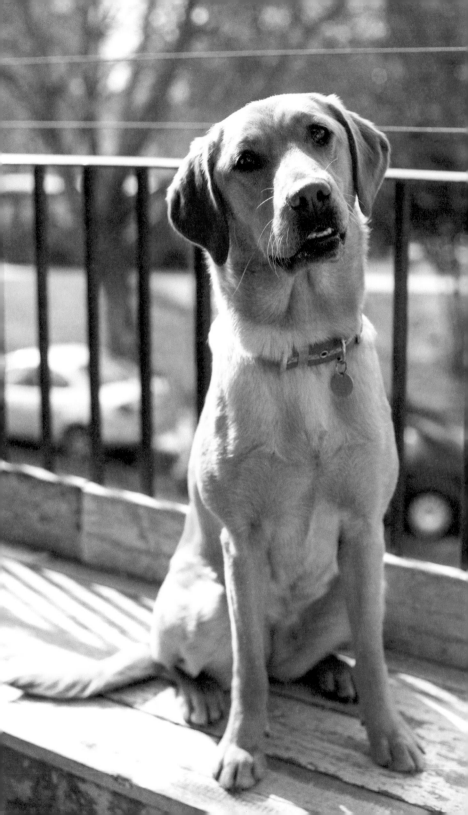

SASCHA

NO. 32 THE OLD TOWN

Labrador Retriever

Where do they sleep
Downstairs in the kitchen!

Favourite things
Bones, socks, chicken wings,
hoover

Most dislikes
Being left downstairs
without company

Favourite place
Battersea Park

Favourite drink
Water, especially from a puddle

When not in pub likes to
Sleep, eat, sleep, eat, run, sleep eat,
run...

Likes cats or loathes cats
Indifferent

Best trick
Being a statue until she is released

Favourite toy
Fluffy duck

Favourite treat
Kong stuffed with peanut butter
& cheese

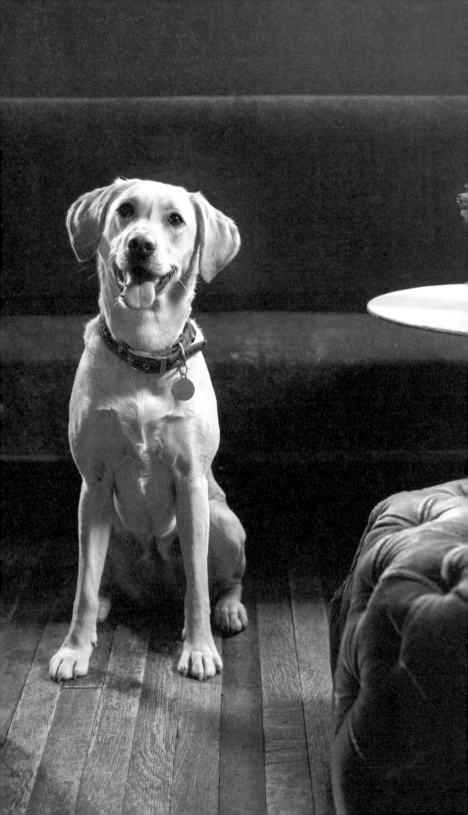

MAGGIE

NO. 32 THE OLD TOWN

Labrador Retriever

Where do they sleep
On a sofa in the kichen or the
end of our bed if she can sneak
in unnoticed

Favourite things
Walks, toys, treats &
paddling pools

Most dislikes
Inanimate objects with faces on
them & mummy's art collection

Favourite place
Battersea Park & Richmond Park

Favourite drink
Water, especially from puddles

When not in pub likes to
Chase tennis balls & cuddle

Likes cats or loathes cats
Scared!

Best trick
Twirling & doing high 5s

Favourite toy
Kong or rope

Favourite treat
Mature cheddar

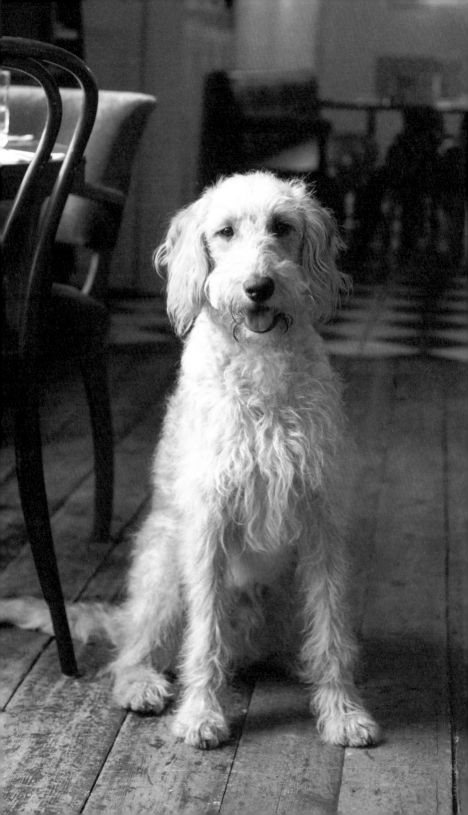

RAMBO

NO. 32 THE OLD TOWN

Labradoodle

Where do they sleep
He has a bed next to ours. Three's company...

Favourite things
Toys, being chased, eating anything & everything, naps & cuddles

Most dislikes
Being alone

Favourite place
Battersea Park

Favourite drink
Water from puddles – the messier the better!

When not in pub likes to
Meet with his friends for walks

Likes cats or loathes cats
Loathes. They are the enemy

Best trick
Standing up

Favourite toy
His squeaky monkey

Favourite treat
Peanut butter

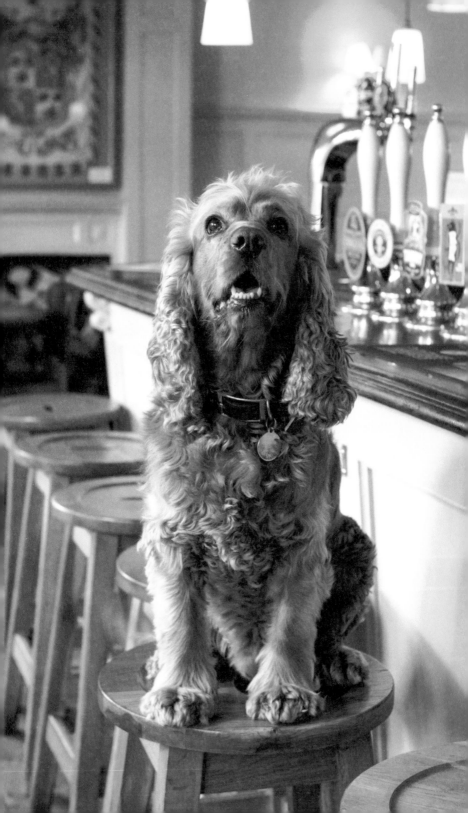

SILVESTER

THE RED LION & SUN

English Cocker Spaniel x
American Cocker Spaniel

Where do they sleep
On his bed (memory foam bed)
in our room

Favourite things
Sleep, sniffing, "snoring"

Most dislikes
"Indie" showers

Favourite place
Hampstead Heath

Favourite drink
Dog beer, goat's milk, H_2O

When not in pub likes to
Sleep

Likes cats or loathes cats
Loathes cats

Best trick
Bang bang, high five & turn around
all at once!

Favourite toy
Indie

Favourite treat
N2 Veal Bones

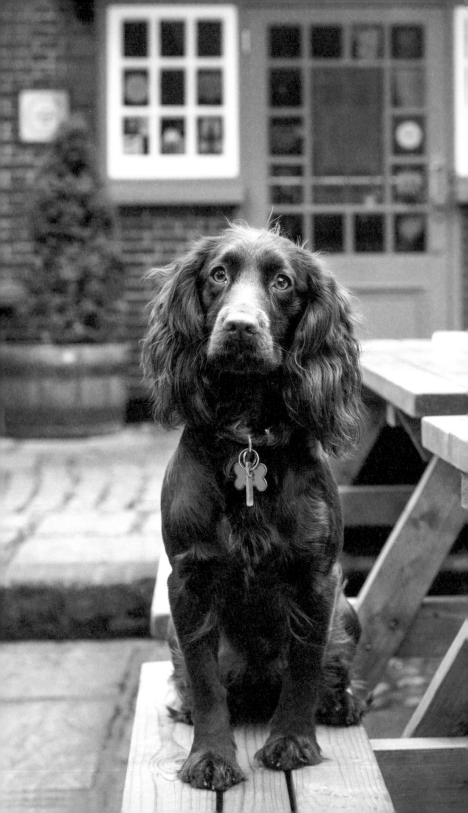

INDIE

THE RED LION & SUN

Working Cocker Spaniel

Where do they sleep
Under our duvet!

When not in pub likes to
Play fetch on Hampstead Heath

Favourite things
Tennis balls, teddy bear, bones,
annoying Silvester

Likes cats or loathes cats
Hasn't met one yet

Best trick
Making you believe she hasn't
been fed today

Most dislikes
Being brushed, grooming

Favourite place
Under the duvet!

Favourite toy
Teddy bear

Favourite drink
Dirty puddle water

Favourite treat
Frozen carrots

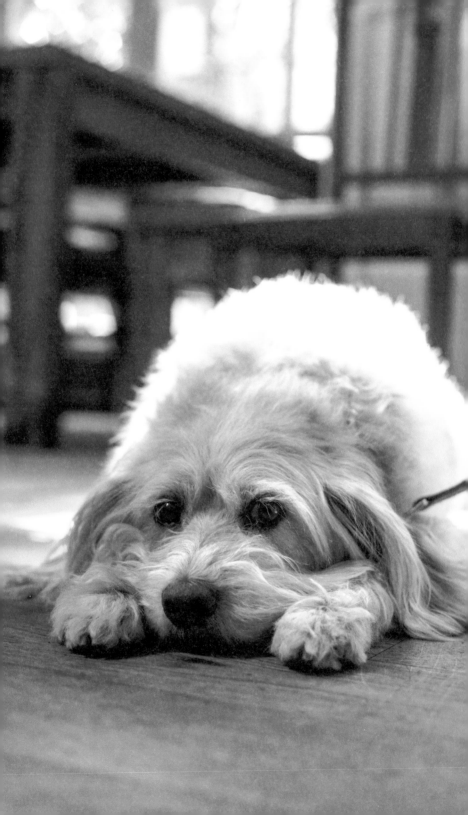

GEORGIE

THE RED LION & SUN

Mongrel

Where do they sleep
In his basket & our bed

Favourite things
Playing with other dogs & chasing
any creature that moves

Most dislikes
Being left

Favourite place
Our garden in France

When not in pub likes to
Be with his pack [my wife & me]

Likes cats or loathes cats
Definitely loathes

Favourite toy
Plastic squeaky hamburger

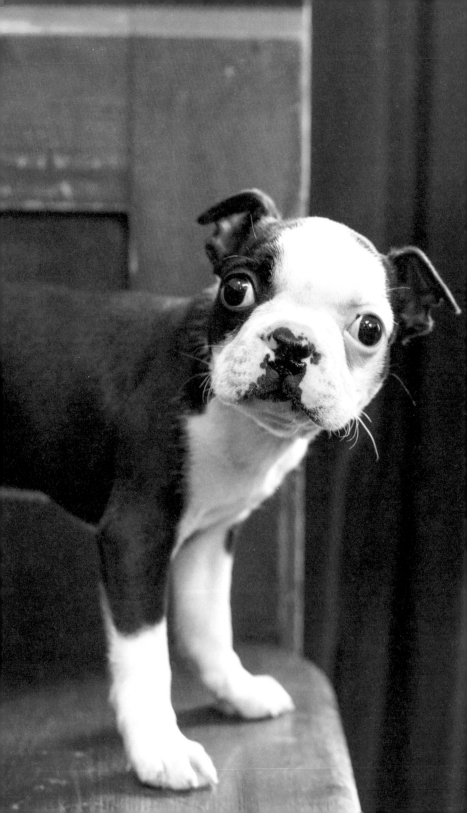

HOOCH

Boston Terrier

THE RED LION & SUN

Where do they sleep
In his bed downstairs

Favourite things
Alligator & monkey soft toys,
& tummy rub

Most dislikes
Not snuggling

Favourite place
Mummy's lap

Favourite drink
Water

When not in pub likes to
Snuggle

Likes cats or loathes cats
Hasn't met one yet

Best trick
Fetching & hopping

Favourite toy
Alligator & monkey

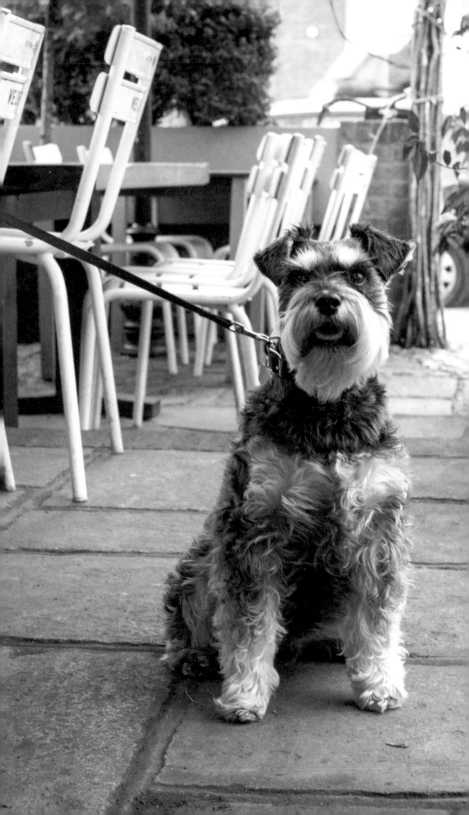

BERTIE

THE RED LION & SUN

Miniature Schnauzer

Where do they sleep
In his crate

When not in pub likes to
Walk

Favourite things
Treats, food

Likes cats or loathes cats
He's never seen one!

Most dislikes
Loves everything except other dogs

Best trick
"High 5"

Favourite place
Home on the sofa

Favourite toy
He's got so many, he has a toy box

Favourite drink
H_2O

Favourite treat
Venison bone

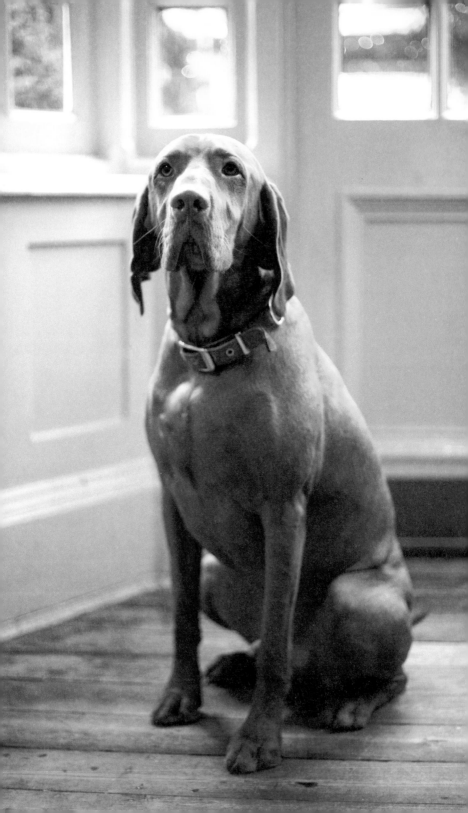

CHEWIE

THE RED LION & SUN

Hungarian Vizsla

Where do they sleep
In the playroom

Favourite things
Catching balls in the park &
NEVER bringing them back,
snuggling on the sofa in the middle
of everyone, guarding the kitchen
at night, door wide open

Most dislikes
Staying at home if we go out – not
sitting at the table like a human

Favourite place
Kenwood Park, our bed

Favourite drink
Muddy water in the park

When not in pub likes to
Curl up in sunny spot, RUN

Likes cats or loathes cats
Chases them! But never got close
enough to find out

Best trick
"Talking" with his eyebrows

Favourite toy
Toy fox

Favourite treat
Raw bones from Sunday
lamb roast

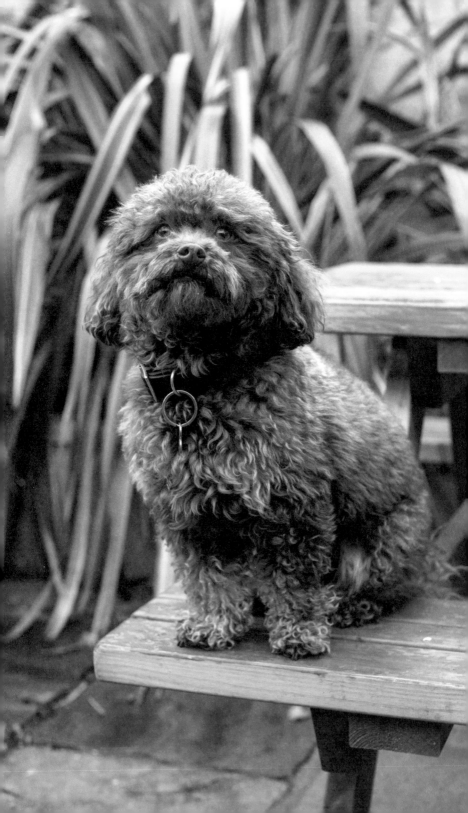

CASTRO

THE RED LION & SUN

Havanese

Where do they sleep
In a basket next to my bed

Favourite things
Me! Long walks, cuddles, treats

Most dislikes
Baths, being away from me!

Favourite place
With me!!

Favourite drink
Water, doggy beer / cider

When not in pub likes to
Walks 'to death' in the park
terrorising other dogs! & rolling in
fox poo – yum yum! Lick me!

Likes cats or loathes cats
Loathes

Best trick
High five, dances

Favourite toy
Anything with a squeak

Favourite treat
Cuddles in my bed! & kale

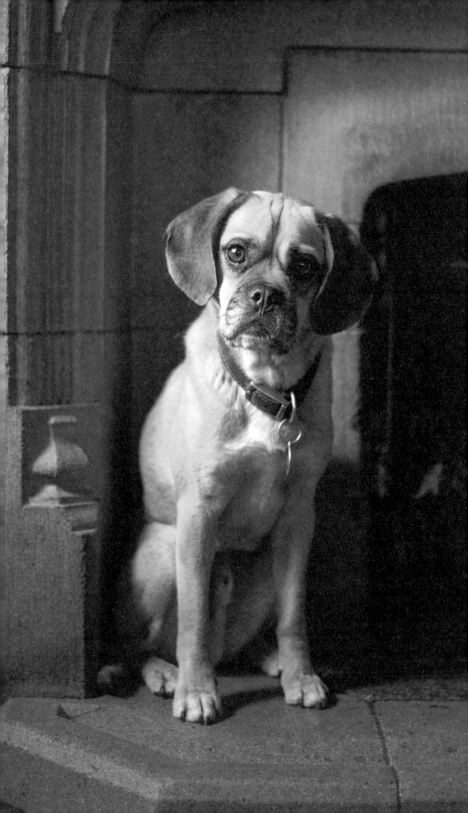

BUSTER

THE BULL & LAST

Puggle

Where do they sleep
In a well-appointed crate in
our kitchen

Favourite things
Food, of all types. Being wedged
between us on the sofa. Being
under the covers. Eating poo

Most dislikes
Being left alone. He's crazy
codependent (not that we've helped
the situation)

Favourite place
Under the covers at our feet

Favourite drink
Water? Don't think he's tried
anything else. Me? The "So solid
brew" pale ale

When not in pub likes to
Run away from us on Hampstead
Heath in search of something gross
to eat. Sleep. But mostly eat

Likes cats or loathes cats
He barks at pretty much anything
that moves including cats

Best trick
Once we reach the tennis courts
on Hampstead Heath he becomes
a heat-seeking missile dragging us
to the pub

Favourite toy
An "indestructible" alligator that's
had all of its stuffing forcibly
removed

Favourite treat
Literally anything. Cheese? Carrots?
Anything

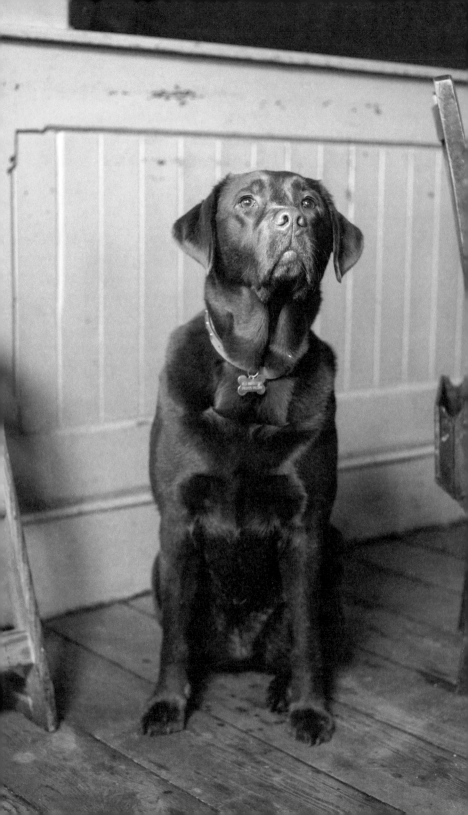

HERSHEY

THE BULL & LAST

Chocolate Labrador

Where do they sleep
Dog bed in kitchen
(sofa when naughty)

Favourite things
Peanut butter, parma ham,
tummy rubs, toys, swimming
for her ball

Most dislikes
Anti-flea treatment, any
medication, being fed late

Favourite place
Hampstead Heath

Favourite drink
Pond water!

When not in pub likes to
Go on long walks, eat! Just be
with us

Likes cats or loathes cats
Loathes

Best trick
Will do anything for carrots –
paws, etc.

Favourite toy
Cuddly monkey

Favourite treat
Gravy bones, chicken,
rawhide chews

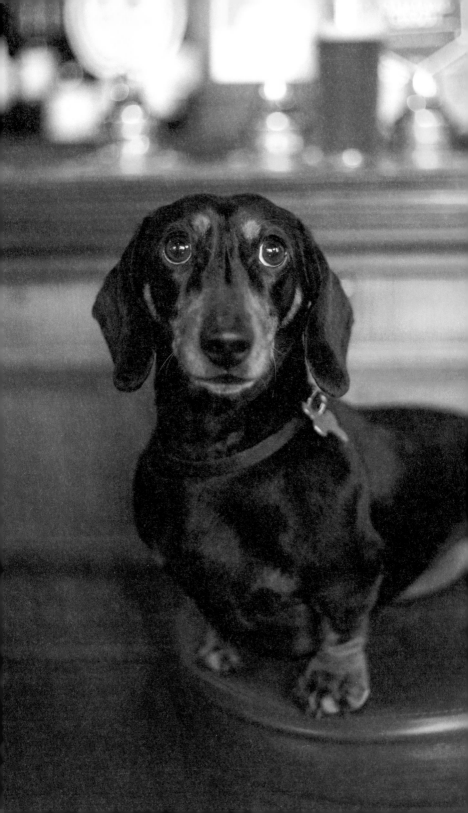

LENNY

THE BULL & LAST

Miniature Short-Haired Dachshund

Where do they sleep
He camps in the hallway in his own
blue tent

Favourite things
Snuggling in bed on a Sunday
morning, sharing a hangover

Most dislikes
Postman

Favourite place
Sitting on the top of the armchair
in the bay window

Favourite drink
Gravy or an IPA

When not in pub likes to
Chase tennis balls. All day

Likes cats or loathes cats
Loathes cats

Best trick
Playing middle spoon,
head on pillow like a human.
Oh, & forward rolls

Favourite toy
Tennis ball

Favourite treat
Lamb bone. Don't dare try to
take it off him

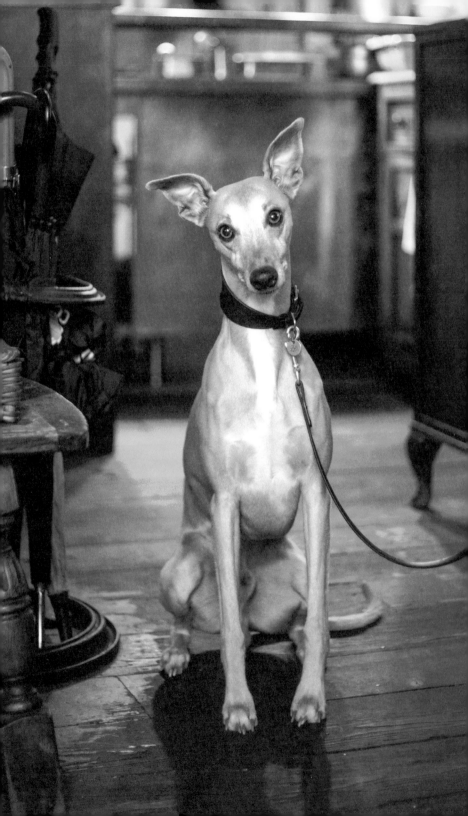

WILLOW

THE BULL & LAST

Whippet

Where do they sleep
In the best bed, under the duvet.
Likes linen, likes blankets. Travels
with blanket & bedding in winter

Favourite things
Tripe. Squirrels. Bottoms. Pals at
the park. Bacon

Most dislikes
Cats

Favourite place
Cold-fall wood, Parliament Hill,
the pub, the couch, the bed

Favourite drink
Puddles, the ones that form in
the nook of a tree after it rains

When not in pubs likes to
Sleep

Likes cats or loathes cats
Loathes cats

Best trick
Pillow thief, & stealer of
your place on the couch,
should you move

Favourite toy
Frisbee, or anything resembling
a bunny that squeaks

Favourite treat
Tripe sticks. Marrow bones

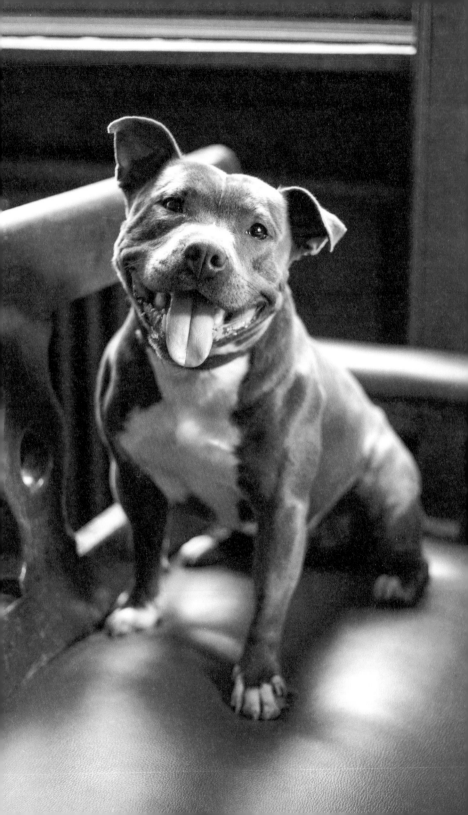

CHULO

Staffordshire Bull Terrier

THE PRINCE REGENT

Where do they sleep
His own mattress but he jumps
behind my knees as soon as he
sees a chance

Favourite things
Walking in Brockwell Park,
chasing his ball & squirrels, tug-
of-wars, & National Geographic
Documentaries

Most dislikes
Vets, baths & been woken up
in the morning

Favourite place
Anywhere near my legs, if it's hot
just near, when it's cold, heavily
resting on them

Favourite drink
Water

When not in the pub likes to
Pee on every tree

Likes cats or loathes cats
He loves cats, unfortunately the
feeling is not reciprocated

Best trick
He rings a bell when he needs to go
out for a wee

Favourite treat
Pig ears & whatever we are eating

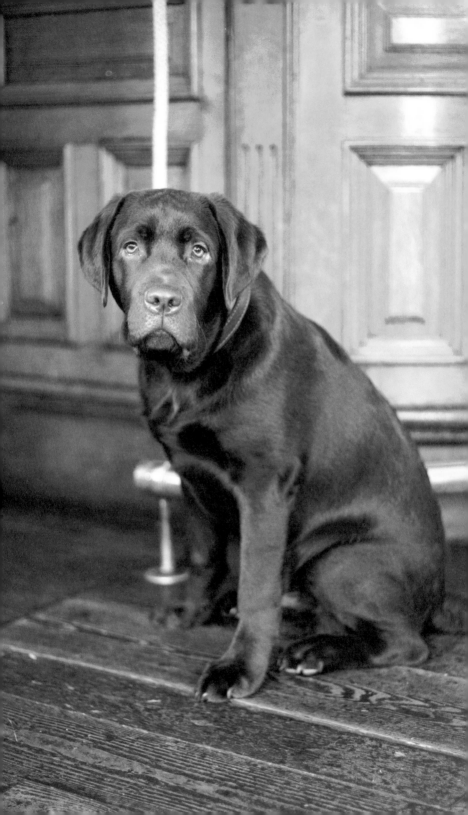

MUD

Labrador

THE PRINCE REGENT

Where do they sleep
In the laundry basket

Favourite things
Eating plants

Most dislikes
Being alone

Favourite place
Brockwell Park, The Prince Regent
(Landlord's dog!)

Favourite drink
Real ale / milk

When not in pub likes to
Sleep!

Likes cats or loathes cats
Loves cats – to chase

Best trick
Carrying his own lead

Favourite toy
Old shoes, new shoes, any shoes

Favourite treat
Tripe sticks

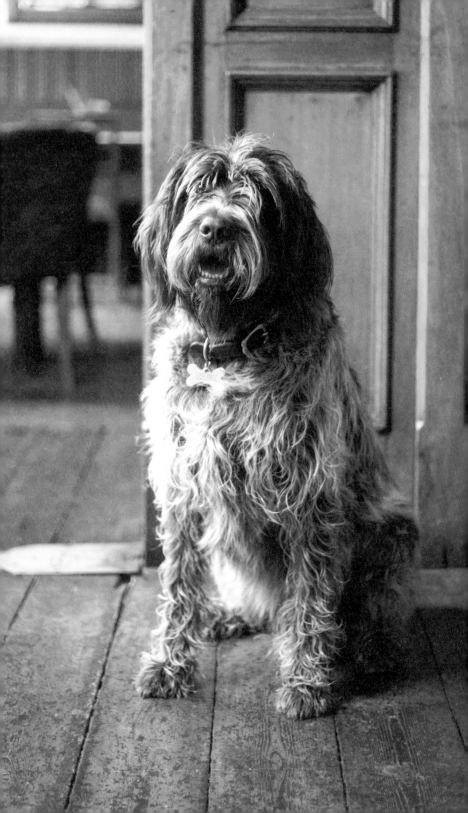

ALBERT

THE PRINCE REGENT

Korthals Griffon

Where do they sleep
Lounge

Favourite things
Kevin his sheep toy, sofa, the car,
muddy water, fox poo

Most dislikes
Sound of wasps & farts

Favourite place
Sofa

Favourite drink
Water

When not in pub likes to
Sleep, keep guard in the garden

Likes cats or loathes cats
Curious

Best trick
Kiss

Favourite toy
Kevin the sheep

Favourite treat
Pig's ears

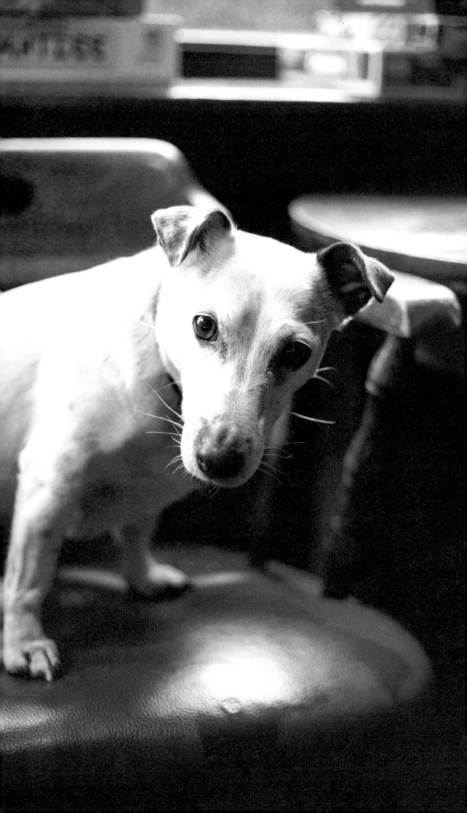

WINNIE

THE PRINCE REGENT

Jack Russell

Where do they sleep
In a basket downstairs in
the kitchen

Favourite things
Running in a figure of eight

Most dislikes
Fireworks

Favourite place
Wide Beaches, Pembrokeshire

Favourite drink
H_2O

When not in pub likes to
Walk, eat, sleep & play

Likes cats or loathes cats
Neither. Wants to chase
& then lick!

Best trick
Catching her "Kong Wubba"
in mid-air

Favourite toy
Squeaky ring

Favourite treat
Any quality meat

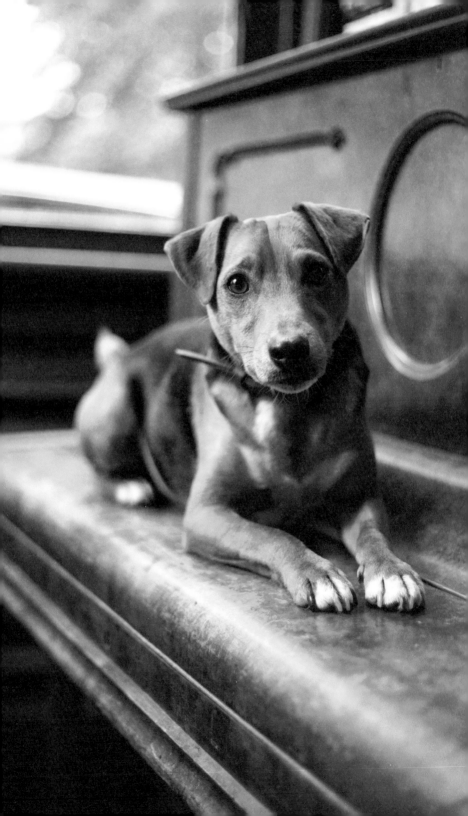

BILL

THE PRINCE REGENT

Terrier

Where do they sleep
On a ridiculously large bean bag

Favourite things
Bones, squirrels, teasing big dogs,
sneaking upstairs to lie on our bed

Most dislikes
Traffic wardens

Favourite place
By the fire or lying in the sun by
his pool (pond)

Favourite drink
Ale spills

When not in pub likes to
Chase anything moving – cats,
pigeons, skateboarders, Shire
horses &/or escape his nice owners
& visit places with food (Covent
Garden Market!)

Likes cats or loathes cats
Wants to eat them

Best trick
Opening doors

Favourite toy
The post

Favourite treat
Cheese

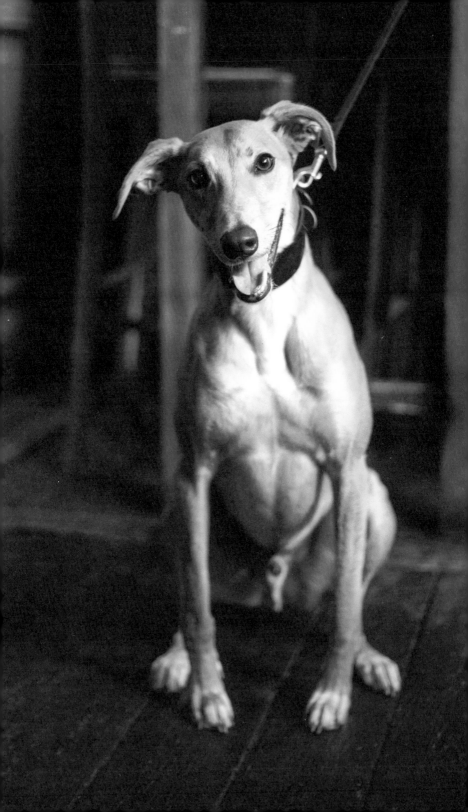

BARRY

THE PRINCE REGENT

Greyhound Cross

Where do they sleep
In the kitchen on a big bed made
for him

When not in pub likes to
Loves being with people &
snoozing

Favourite things
Balls – has 5 in front room

Likes cats or loathes cats
Doesn't mind cats, but will chase
them sometimes

Most dislikes
Occasionally jealous of other dogs

Best trick
He speaks

Favourite place
Brockwell Park

Favourite toy
Chewing his balls

Favourite drink
Water

Favourite treat
Beef strips & ham bones

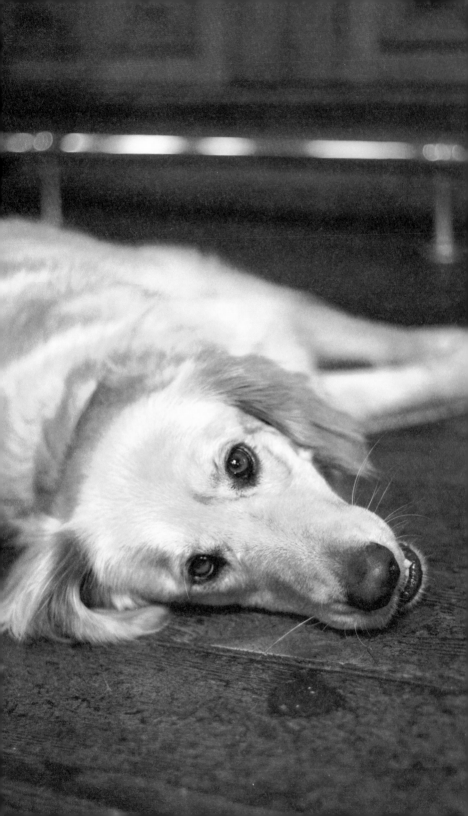

ZAKI

THE PRINCE REGENT

White Alsatian x Cocker Spaniel

Where do they sleep
Doggy mattress

When not in pub likes to
Run in the park

Favourite things
Chasing Squirrels

Likes cats or loathes cats
Loathes, likes to chase them

Most dislikes
Metallic noise (skateboards etc.)

Best trick
Give paw!

Favourite place
Seaside

Favourite toy
Big sticks

Favourite drink
Water

Favourite treat
Chicken

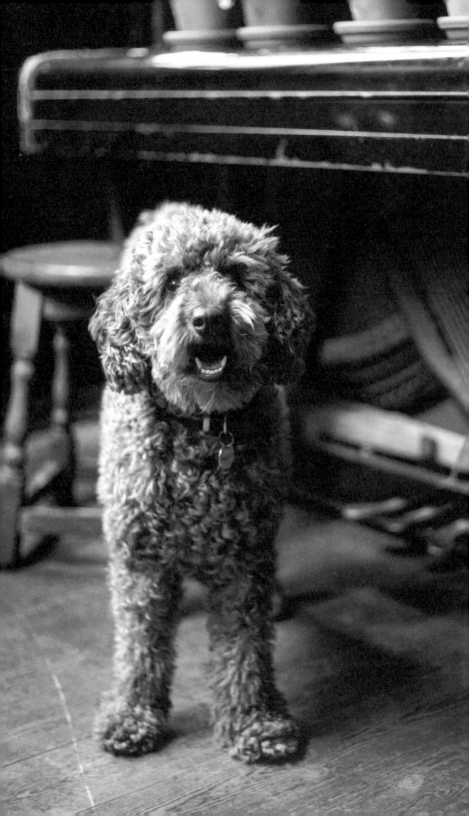

ALFIE

ROSEMARY BRANCH

Miniature Poodle

Where do they sleep
Anywhere & everywhere.
He is the king of the castle

Favourite things
Playing with his buddies at the park. Food & sleeping. He has a 2nd bed full of toys & picks one out at a time & brings them to you to play with him

Most dislikes
Big dogs playing rough

Favourite place
The beach, Hamstead Park, also his local park Shoreditch Haggiston Rosemary. Also frequenting all of his dad's favourite local pubs

Favourite drink
Water, milk, Actimel

When not in pub likes to
Play with his toys at home, not sharing. Playing out at the park with his buddies

Likes cats or loathes cats
Likes but they don't seem to be fond of Alfie

Best trick
Counting trick 2 + 2 = 4 (Left hand) or 5 (right hand). Only wife can make him do it.

Favourite toy
So many. But anything with a squeaker in it

Favourite treat
Parma ham, salami

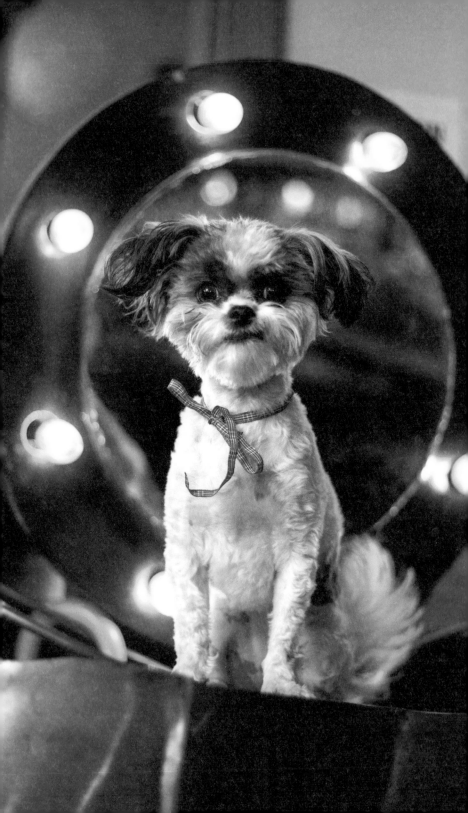

ANNIE

ROSEMARY BRANCH

Chichon (Bichon x Chihuahua)

Annie's Date

Love me. Please love me.
Love me because
I'm completely gorgeous,
sitting here prettily
with my very own mirror
and its lovely bulbs
to light up my face.

It looks a bit like a halo.

All you have to do is gaze
into my eyes
and you'll be under my spell.

I'm small, but perfectly formed.
They should have
called me Kylie.

I'm a diva. A supermodel.
I'm She Who Must Be Obeyed.
I always demand
freshly cooked pieces of chicken
in my dressing kennel,
and a Fabergé egg cup full
of milk!

Most of my friends take cocaine
and are always
being photographed
falling out of taxis
and flashing their knickers,
but that's not for me
(and I don't wear knickers).

Just one look.
That's all it takes.

Have you ever seen
anything as lovely in your life?
I'm talking about me.
Me, sitting, here, looking
completely stunning.

Excuse me, but I have to dash.
I've got a date with a dog
called Huey.

He says he's going to show me
'a good time, darlin', whatever
that means.

ANNIE

Where do they sleep
Officially at the end of my bed but at some point during the night she'll come & get into bed next to me like a little person!

Favourite things
She was/is raised in a pub (Barley Mow, Shoreditch) & loves to come down to check who's in! Thrives on company, running fast & watching nature programmes!

Most dislikes
She's not bothered by much — we live in a bustling (noisy!) area. She doesn't like to be on her own too long

Favourite place
She loves her pub first but also wide open spaces & is looking forward to her first holiday in St. Ives later this year

Favourite drink
She's been known to have a bit of beer foam in the bar! She also likes an egg cup full of milk for a treat

When not in pub likes to
Meet up with her mates (girl dogs mainly!) — she has quite a gang of all shapes & sizes

Likes cats or loathes cats
Annie's motto is: "Come one, come all!"

Best trick
We have to admit that what she makes up for in adorableness, she perhaps lacks in the brain department!

Favourite toy
My flip flops — who knows why!

Favourite treat
Chicken pieces

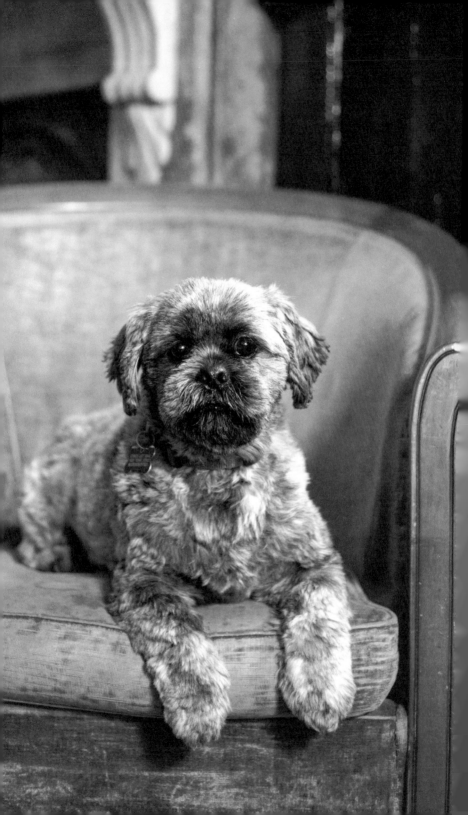

HUMPHREY ROSEMARY BRANCH

Lhasa Apso

Where do they sleep
Anywhere soft i.e. the bed!

Favourite things
Wildlife programmes on TV
& anything with dogs in

Most dislikes
Theme tune to "Eastenders"

Favourite place
Back of the car on long journeys

Favourite drink
Filthy ditch water or Evian

When not in pub likes to
Bark at foxes, guard the house,
be cuddled

Likes cats or loathes cats
Hates Next Door's cat, loves all
other cats

Best trick
The splits

Favourite toy
My feet

Favourite treat
Smoked salmon

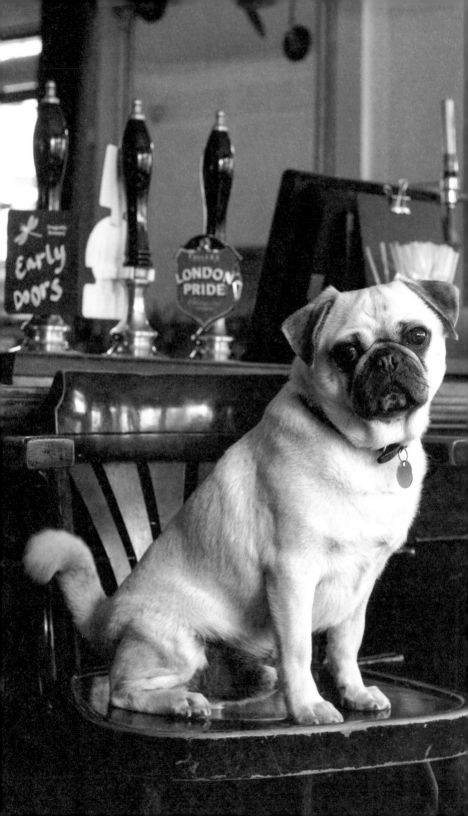

LUDWIG

ROSEMARY BRANCH

Pug(ish)

Where do they sleep
In the sun

Favourite things
Food, Sophie the Giraffe, cuddling
on the bed, playing rough,
chasing whippets

Most dislikes
Taiko drums, statues, loud bangs,
being mounted!

Favourite place
On the beach, frolicking with
other dogs

Favourite drink
Smelly lake water

When not in pub likes to
Run down the canal & say
hello to everyone

Likes cats or loathes cats
Likes, but has yet to be
formally introduced

Best trick
"Kiss Nicole" – will give people
kisses on demand

Favourite toy
Sophie the Giraffe & his
reindeer pelt

Favourite treat
Roquefort

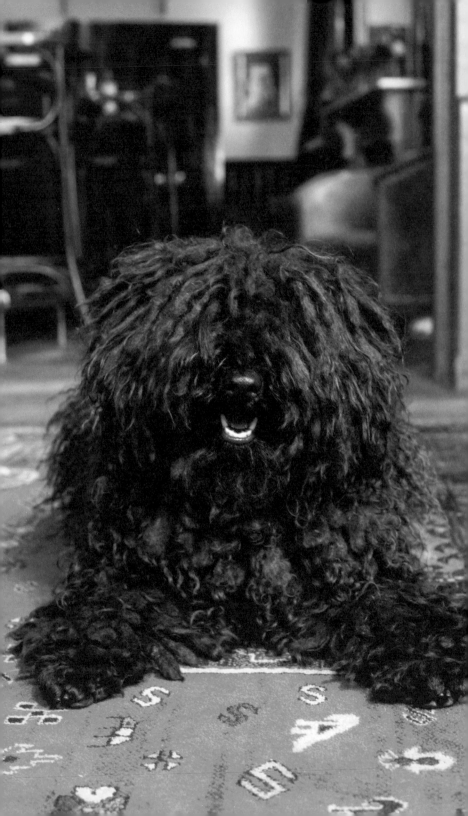

FRIDA

ROSEMARY BRANCH

Hungarian Puli

Frida's Fringe

Hello. I'm Frida.

I'm a walking mop.

It's not easy being
a walking mop.
If I stand still for 5 minutes
before I know it
someone has stuck a pole
up my bum
and I'm being swept
across the floor.

I always do a good job.
No complaints.
Five stars.

I can't see a thing.
I haven't seen my paws in years.
I don't know if
it's dark or light.

Maybe I should start a business.
Hire myself out
and earn a few bones.

Or maybe it's best
just to go with the flow,
not know what's in front
of you
or where
you are heading.

Each day a new beginning.

A clean slate.

The only comfort I have
is my stinky sausage.
At least
I think it's a stinky sausage.
It could be anything.

I just put it in my mouth
and bite.
Whatever gets you
through the night.

MOP FOR HIRE!
BRING YOUR OWN POLE!

FRIDA

Where do they sleep
On her bed, next to my bed

Favourite things
Pigeons, tennis balls, footballs.

Most dislikes
The hoover, bin bags, the rat tunnel

Favourite place
Any park, heath or woodland

Favourite drink
Water!

When not in pub likes to
Herd pigeons, join in other people's piggy in the middle, football games

Likes cats or loathes cats
Loves cats

Best trick
Twirling / spinning

Favourite toy
Her football

Favourite treat
Stinky sausage

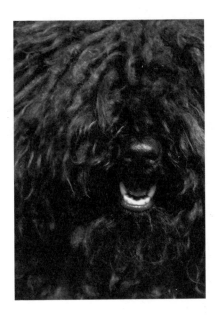

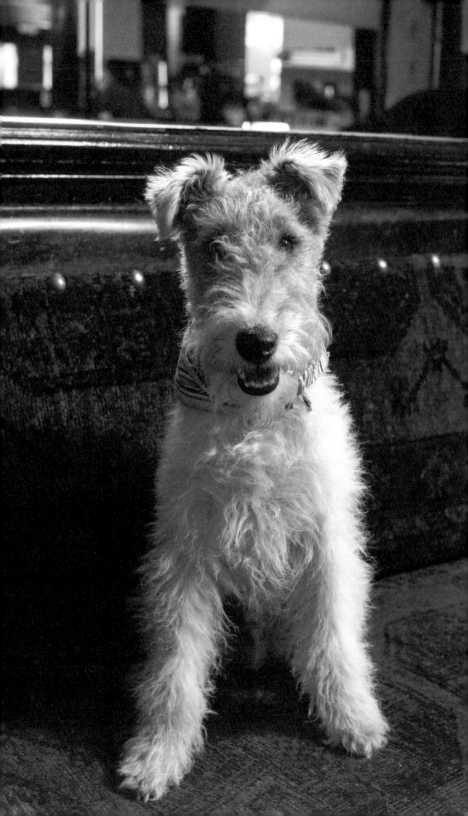

HUMPHREY ROSEMARY BRANCH

Wire Fox Terrier

Where do they sleep
On the bed, in front of the window

Favourite things
Chasing birds, watching "Pet Rescue", sitting in the window watching the passers-by

Most dislikes
Being told "No!", waking up in the morning, cats

Favourite place
The seaside, sitting with Dad in the pub

Favourite drink
Guinness

When not in pub likes to
Go walkies, drive along the embankment

Likes cats or loathes cats
Loathes

Best trick
Getting his own way

Favourite toy
Horsey

Favourite treat
Pizza crusts

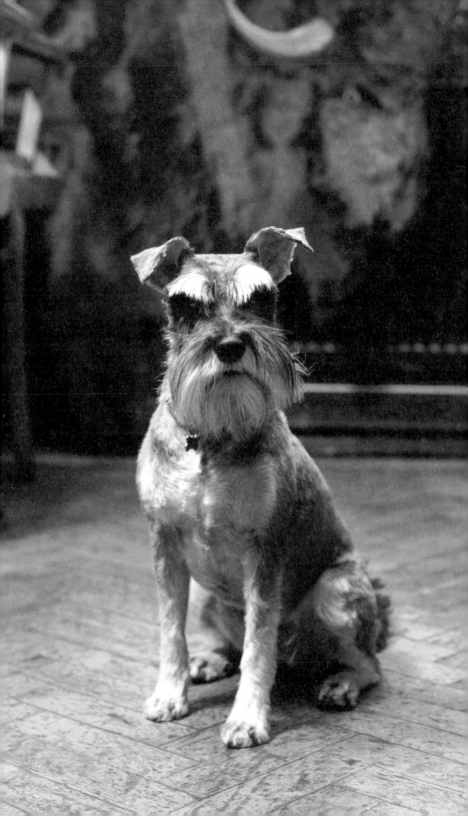

RICCI

Miniature Schnauzer

ROSEMARY BRANCH

Where do they sleep
On the bed!

Favourite things
Schnauzer slippers

Most dislikes
Noisy kids running

Favourite place
Camber Sands

Favourite drink
My beer!

When not in pub likes to
Hunt for food!

Likes cats or loathes cats
Loathes

Best trick
Pirouetting on her back legs
for a doggy treat

Favourite toy
Goose with rope legs

Favourite treat
Liver treats

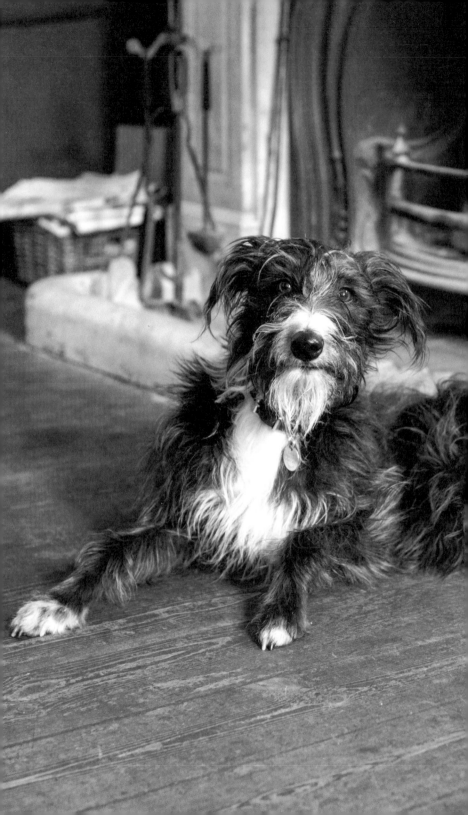

PIPPERTY

ROSEMARY BRANCH

Lurcher

Where do they sleep
On a brown corduroy chair in
the lounge

When not in pub likes to
Hunt squirrels & chase anything
that moves

Favourite things
Chasing anything or being chased

Likes cats or loathes cats
Would love to catch a cat

Most dislikes
Being alone

Best trick
Being the fastest dog in the park

Favourite place
Wepre woods, North Wales

Favourite toy
Rubber bouncy ball

Favourite drink
Water with milk in

Favourite treat
Chicken skin

POMPIDON
ROSEMARY BRANCH

British Bulldog

Where do they sleep
In the bed with his owners

Favourite things
Barking, snoring, playing,
massages &, of course, food

Most dislikes
Noisy lorries, raw parsnips

Favourite place
Mum & dad's bed

Favourite drink
Water

When not in pub likes to
Say hello to people

Likes cats or loathes cats
Likes cats

Best trick
I'm not that kind of dog

Favourite toy
Anything chewable & squeaky

Favourite treat
Sardines in tomato sauce

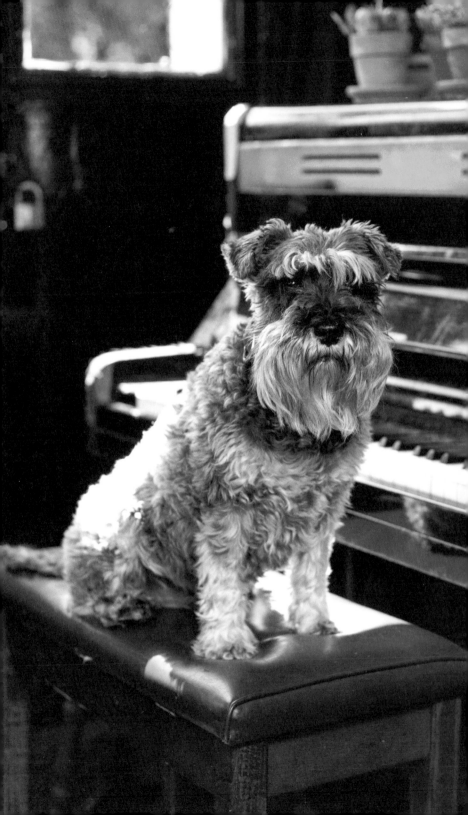

PEARL

ROSEMARY BRANCH

Miniature Schnauzer

Where do they sleep
In my bed

Favourite things
Foxes, the seaside & ice cream

Most dislikes
Swans & children on scooters

Favourite place
Camber Sands

Favourite drink
Banana & peanut butter milkshake

When not in pub likes to
Chase pigeons

Likes cats or loathes cats
Has 2 cats of her own, Ethel & Dolly

Best trick
High Five

Favourite toy
Captain Haddock

Favourite treat
Doggie popcorn

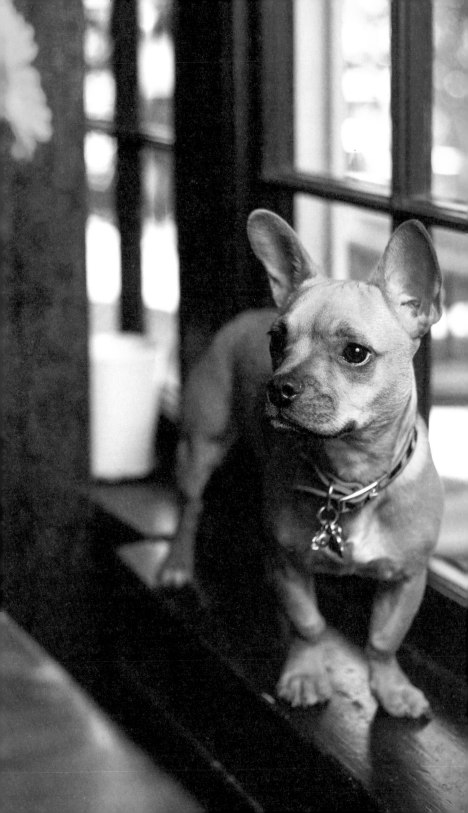

MABEL

THE SPANIARDS INN

French Bulldog x Jack Russell

Where do they sleep
Bed!

When not in pub likes to
Eat

Favourite things
Food

Likes cats or loathes cats
Loathes

Most dislikes
Eye drops!

Best trick
Hasn't got one yet

Favourite place
Park chasing other dogs.

Favourite toy
Mr. Fox soft toy

Favourite drink
Water

Favourite treat
Not discerning – any treat will do

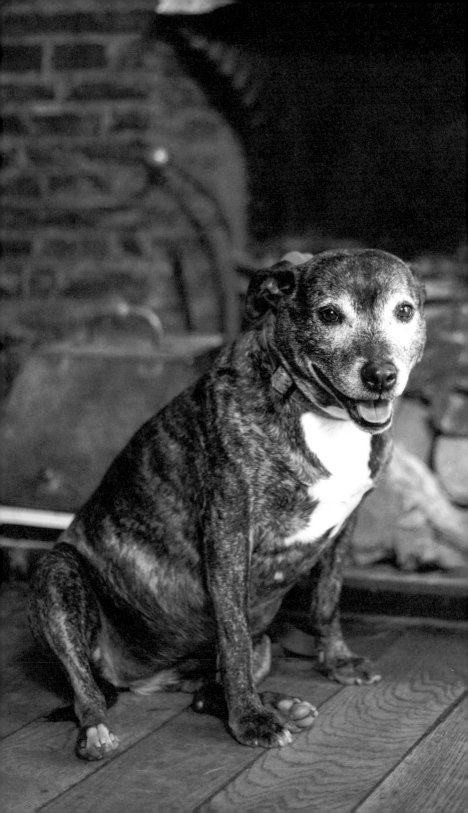

ABI

Staffordshire Bull Terrier

THE SPANIARDS INN

Where do they sleep
In bed with me!

Favourite things
Food & walks, going for dinner
to the pub!

Most dislikes
The rain!

Favourite place
Hampstead Heath

Favourite drink
Perrier

When not in pub likes to
Sleep!

Likes cats or loathes cats
Hates them!

Best trick
Looking sad.

Favourite toy
The monkey

Favourite treat
Chicken

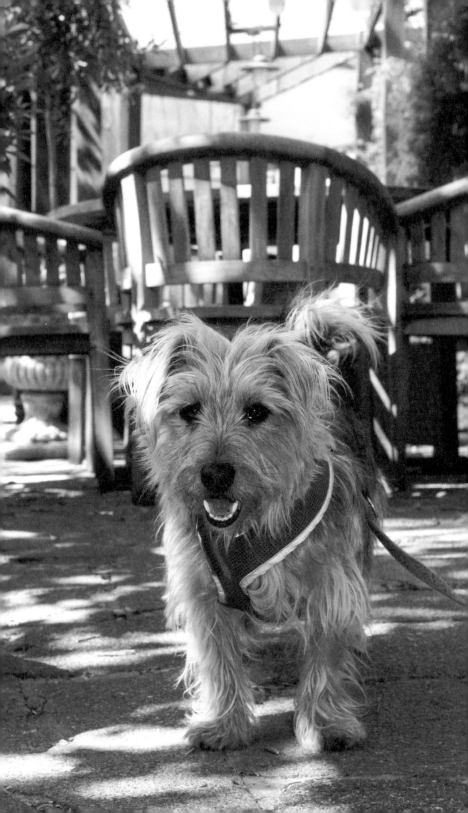

TEDDI

THE SPANIARDS INN

Yorkie

Where do they sleep
In bed

When not in pub likes to
Annoy me

Favourite things
Squeaky toy

Likes cats or loathes cats
Hates!

Most dislikes
Squirrels

Best trick
Belly rubs

Favourite place
The park

Favourite toy
Teddy

Favourite drink
Evian

Favourite treat
Chicken

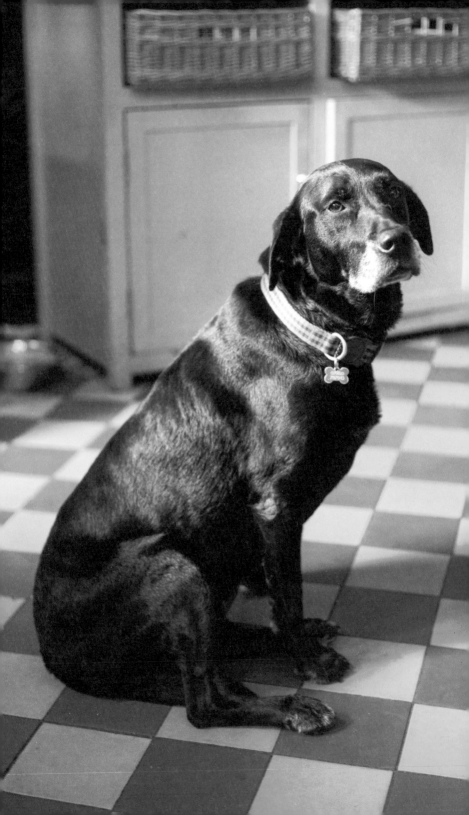

ANNABEL ## THE CHAMPION

Black Labrador

Where do they sleep
In her bed. On my/our bed at night.

Favourite things
Food!!!

Most dislikes
Squirrels

Favourite place
Chasing squirrels in Hyde Park

Favourite drink
Water

When not in pub likes to
Eat. Eat anything

Likes cats or loathes cats
Not bothered

Favourite toy
Stuffed squeaky squirrel that she shakes in practice in case she is ever able to catch one in Hyde Park!!! ... Not very likely!

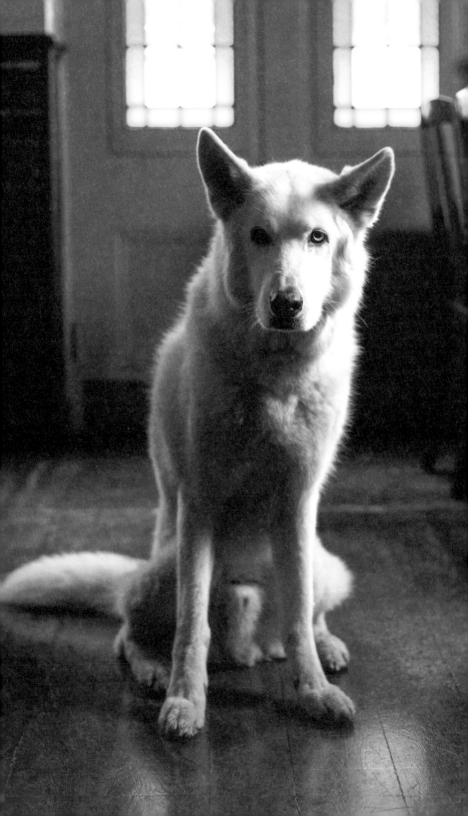

CHARLES
THE CHAMPION

Alaskan Malmute x German Shepherd x Husky

Where do they sleep
On the bed or sofa. Wherever they want!

Favourite things
Walks in Hyde Park

Most dislikes
The fact that I have a boyfriend who took his place on the sofa

Favourite place
Chilling at home

Favourite drink
Water

When not in pub likes to
Go for long walks

Likes cats or loathes cats
Not bothered by them at all. Total disdain

Best trick
Wrapping his lead around his nose while leaping in the air like a dolphin!

Favourite toy
Not interested

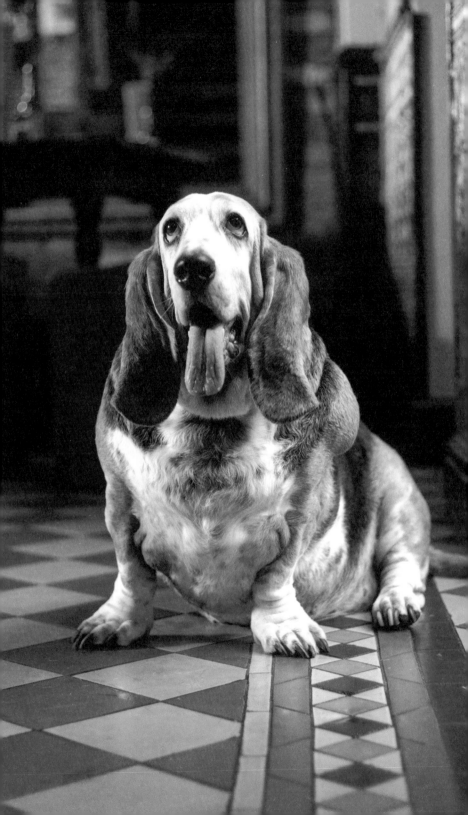

BLOSSOM

THE CHAMPION

Basset Hound

Blossom's Equation

I might be old,
but I've still got a tongue
that's longer than yours!

A bowl of stolen food
and a sloppy pink tongue.

What more do you need?

I like to let it hang out
at every opportunity.
Waggle it in the faces
of all these
young whippersnapper pups
with their tablets and apps,
their ipods and pads.

Who needs an Android
when you've got a tongue
the length of the Thames?

It makes me look intelligent.
It makes me look like
Albert Einstein,
a clever High One I've
vaguely heard of.

He liked sticking his tongue out.
He liked telling us his theories
about the Universe.

Who needs a theory
when you've got a tongue
the length of the Milky Way?

Who needs a Universe
when there's a drawer full
of knickers and pants
you can ransack?
Oh yes,
and a toy monkey
to drag around the park.

Monkeys and food
and knickers and tongues.

m+f+k+t

= My theory of everything.

BLOSSOM

Where do they sleep
My bed & her basket

When not in pub likes to
Go to the park

Favourite things
Food, knickers & pants

Likes cats or loathes cats
Likes cats

Most dislikes
Going out in the rain

Best trick
Stealing my dinner

Favourite place
Kensington Park, Holland Park

Favourite toy
Monkey

Favourite drink
Ice water

Favourite treat
Baker's rewards

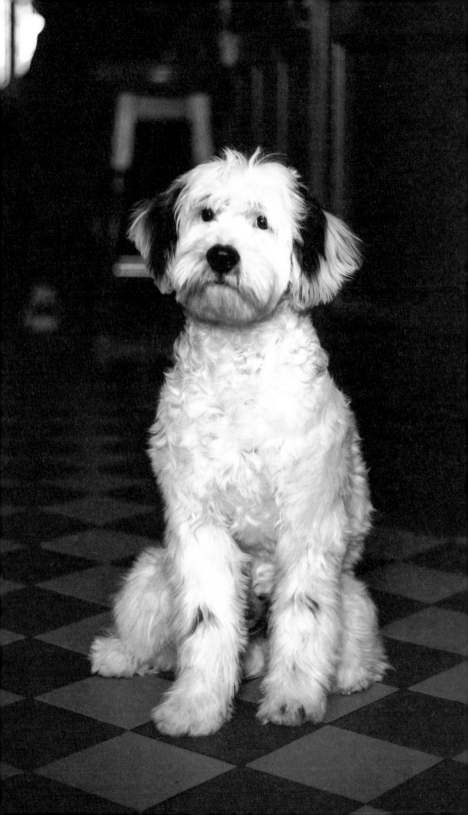

LUCKY

THE CHAMPION

Tibetan Terrier

Where do they sleep
In the kitchen next to his food bowl

Favourite things
Playing with other dogs in the park

Most dislikes
Pigeons

Favourite place
Wherever there is another dog to
play with – park, pub, wherever

Favourite drink
Chicken stock

When not in pub likes to
Play

Likes cats or loathes cats
Curious but indifferent. Wary.

Best trick
Jumping up on the table to try &
steal some dinner

Favourite toy
Soft teddy bear

Favourite treat
Carrots & apples

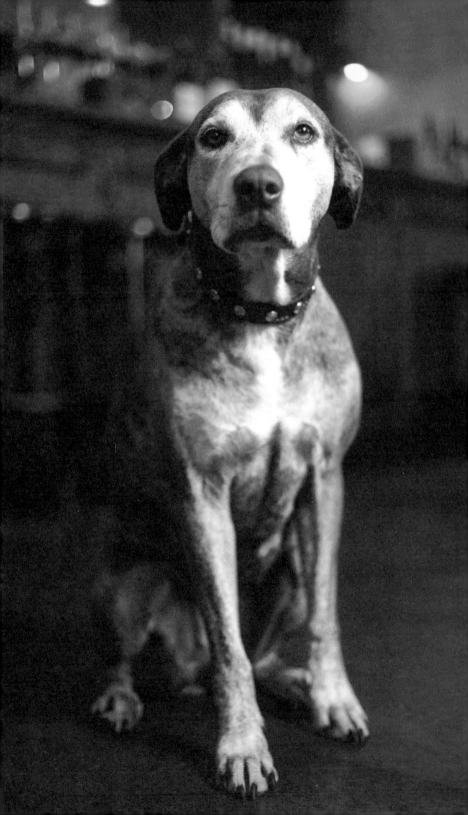

RONNIE

THE ROSENDALE

Mongrel

Where do they sleep
In my bed

Favourite things
Anything that involves myself
especially likes sharing the stage

Most dislikes
Baths

Favourite place
Brockwell Park

Favourite drink
Water

When not in pub likes to
Gallop around with other dogs

Likes cats or loathes cats
Lives with two rescue cats & they
get on fabulously

Best trick
Eliciting food from strangers

Favourite toy
Large bits of wood

Favourite treat
Venison sausage

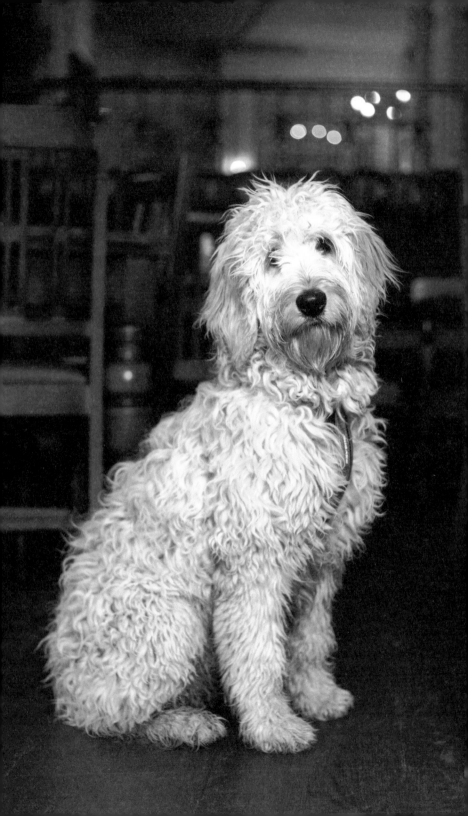

PIPPI

THE ROSENDALE

Goldendoodle

Where do they sleep
In the kitchen living room area

Favourite things
Running in the park,
going into mud

Most dislikes
Going for a ride

Favourite place
Park

Favourite drink
Water

Likes cats or loathes cats
Like cats but doesn't realise they
don't like to be chased

Best trick
Roll over

Favourite toy
Cuddly monkey

Favourite treat
Big bones

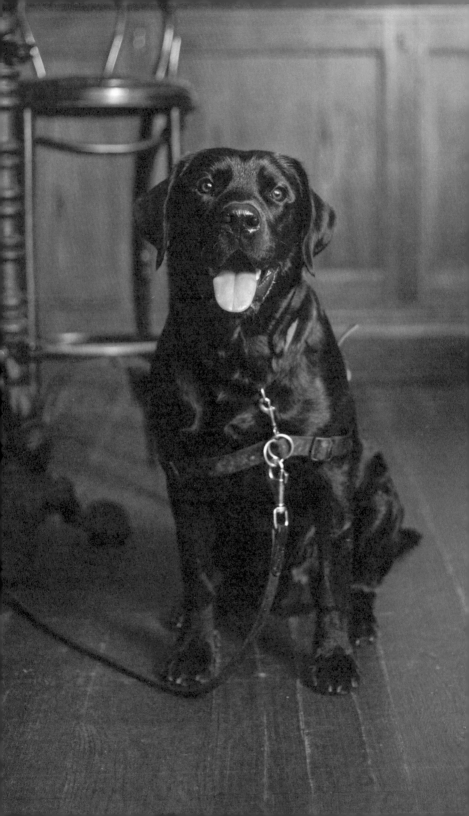

KOBA

Labrador

THE ROSENDALE

Where do they sleep
By our bed!

Favourite things
Tennis balls, food, sleep, my wife, me

Most dislikes
Dogs who steal his tennis ball

Favourite place
Belair Park

Favourite Drink
Water!

When not in pub likes to
Chase tennis balls in Belair Park, sleep

Likes cats or loathes cats
Loathes

Best trick
Catching tennis balls mid-air

Favourite toy
Tennis ball

Favourite treat
Fish skin

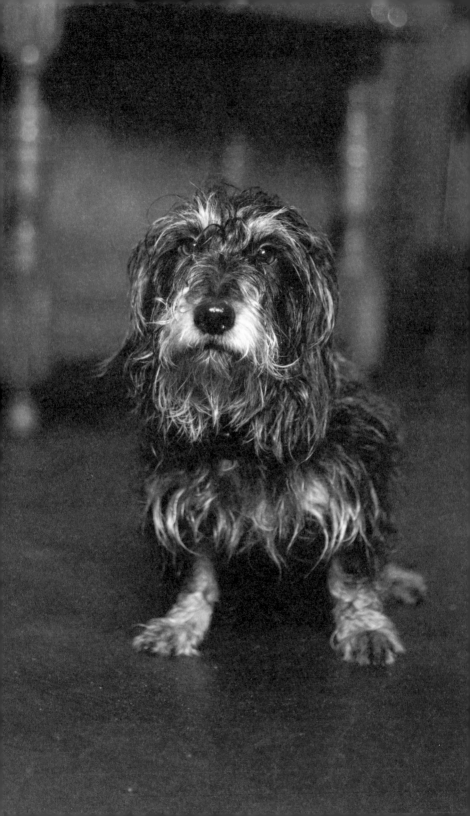

RUFUS

THE ROSENDALE

Miniature White Haired Dachshund

Where do they sleep
In owner's bedroom

When not in pub likes to
Walk in woods

Favourite things
Fetching ball, stroking his tummy

Likes cats or loathes cats
Indifferent

Most dislikes
Rain

Best trick
Looking cute & wagging tail

Favourite place
Dulwich Park

Favourite toy
Fluffy pheasant

Favourite drink
Plenty of water

Favourite treat
Dried chicken

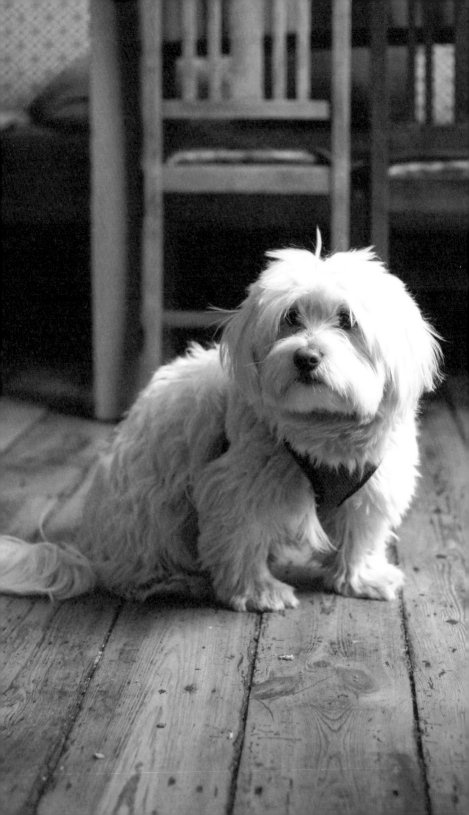

SMUDGE THE QUEEN'S

Coton de Tulear

Where do they sleep
Bed

Favourite things
Sausages

Most dislikes
Men with hoods

Favourite place
Primrose Hill

Favourite drink
Water

When not in pub likes to
Sleep

Likes cats or loathes cats
Likes

Favourite toy
Squeaky lion

Favourite treat
Peanut butter

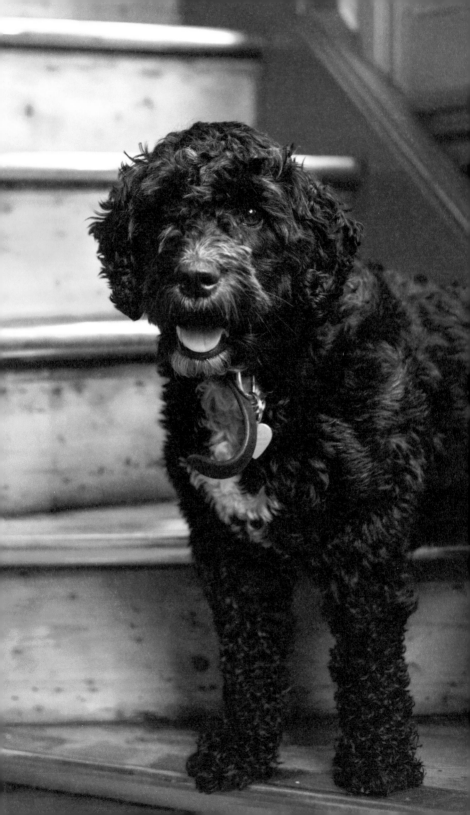

BEAR

THE QUEEN'S

Cockapoo (Cocker Spaniel x Poodle)

Where do they sleep
Sofa

When not in pub likes to
Run

Favourite things
Running & chicken

Likes cats or loathes cats
Hates cats

Most dislikes
Grooming

Best trick
Barks at old men

Favourite place
Hampstead Heath

Favourite toy
Teddy

Favourite drink
Beer

Favourite treat
Chicken bits

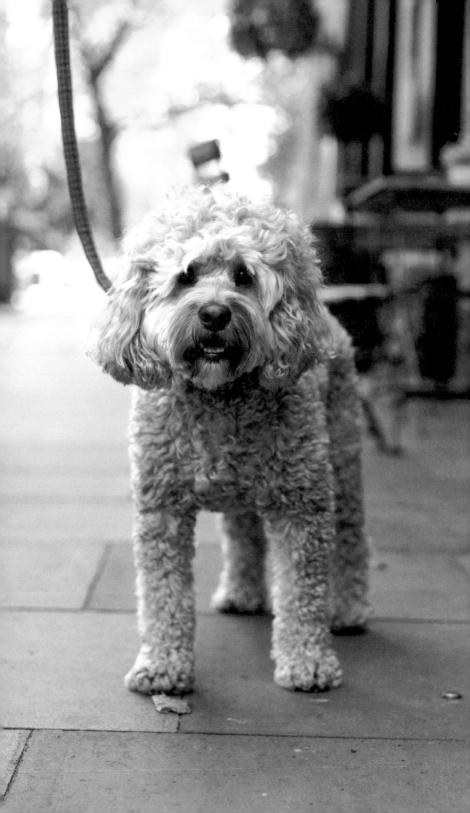

RUSTY

THE QUEEN'S

Cockapoo (Cocker Spaniel x Poodle)

Where do they sleep
On my bed

Favourite things
Brown Ted, owl, my husband & I!

Most dislikes
Hair brushing

Favourite place
Primrose Hill & the Queen's Pub,
as they have good treats!

Favourite drink
Tea!

When not in pub likes to
Run around & play football
with my husband

Likes cats or loathes cats
Loathes

Best trick
Begging for food! i.e. sitting
looking pretty

Favourite toy
Brown Ted

Favourite treat
Anything, especially if on my plate

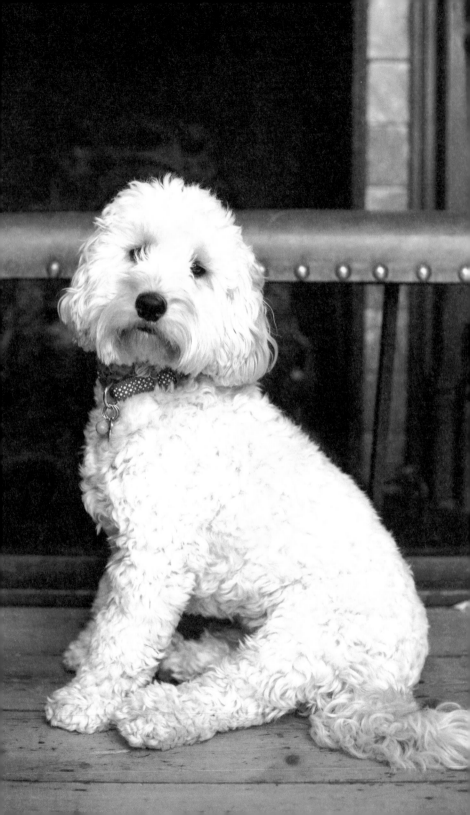

RUBY

THE QUEEN'S

Cockapoo (Cocker Spaniel x Poodle)

Where do they sleep
In their basket

When not in pub likes to
Run & run & run

Favourite things
Ball, tug games, soft toys

Likes cats or loathes cats
Not sure!

Most dislikes
The hoover

Best trick
Catching the ball

Favourite place
The garden

Favourite toy
A soft toy duck

Favourite drink
Beer

Favourite treat
Any food!

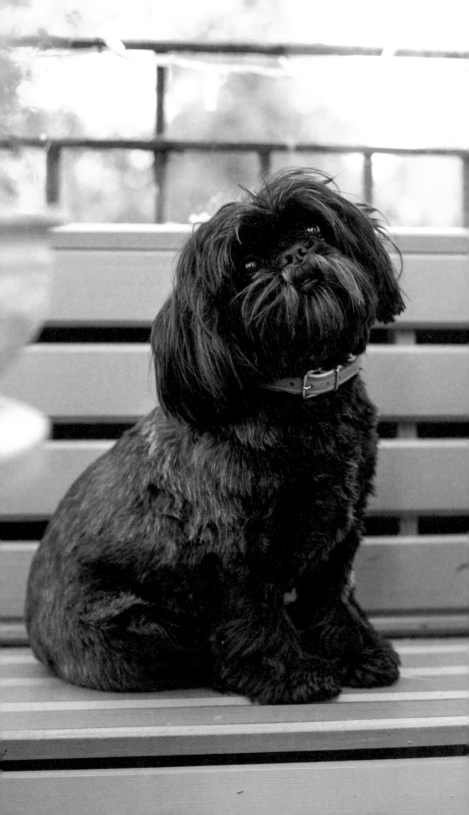

POPPY

THE QUEEN'S

Shih Tzu

Where do they sleep
In mom & dad's bed

Favourite things
Her blankets that her Grandma
Rosa made for her. Her family,
her squeaky toys

Most dislikes
Poeple who are afraid of her

Favourite place
Mom's bed

Favourite drink
Water

When not in pub likes to
Sleep

Likes cats or loathes cats
Likes

Best trick
Chasing tail

Favourite toy
Her blanket

Favourite treat
Chicken from Harry Morgan's Deli

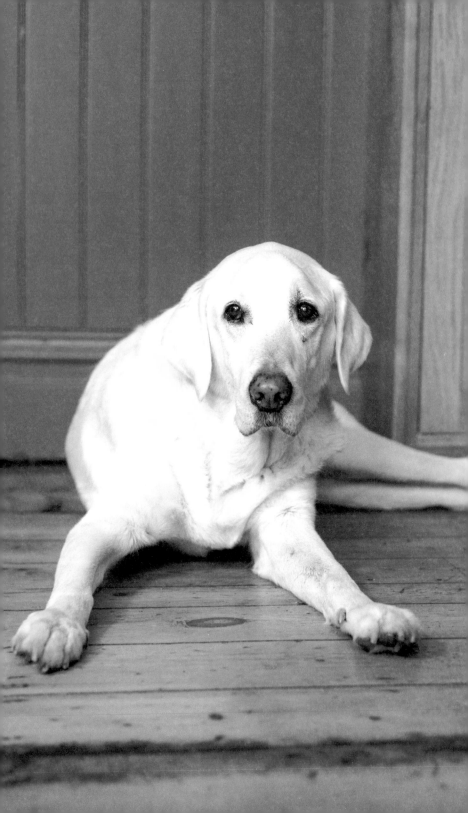

TOBY

THE QUEEN'S

Labrador Retriever

Where do they sleep
In with me & my partner on either one of his own beds

When not in pub likes to
Be with his mum, the Primrose Eatery & be King of the Hill

Favourite things
Food, park, ball & me!

Likes cats or loathes cats
Ignores cats

Most dislikes
Ears & front paws being touched, lively young puppies, not being in charge

Best trick
Storming off when he thinks something is unjust

Favourite place
Primrose Hill

Favuorite toy
Ball

Favourite drink
Water

Favourite treat
Chicken

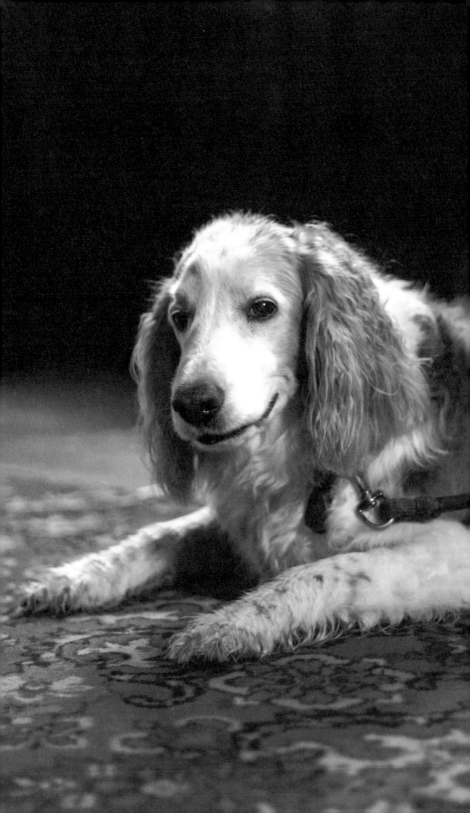

BUSTER

THE CHURCHILL ARMS

Welsh Springer Spaniel

Where do they sleep
On my bed in the master
bedroom

Favourite things
Cheese from the pub at
Sunday lunch

Most dislikes
Fireworks

Favourite place
Kensington Gardens

Favourite drink
Water

When not in pub likes to
Take long walks in the park,
swimming

Likes cats or loathes cats
Wary

Best trick
Snap your fingers & I will give you
my paw in exchange for a treat

Favourite toy
Tennis ball

Favourite treat
Bits from Sunday roast lunch

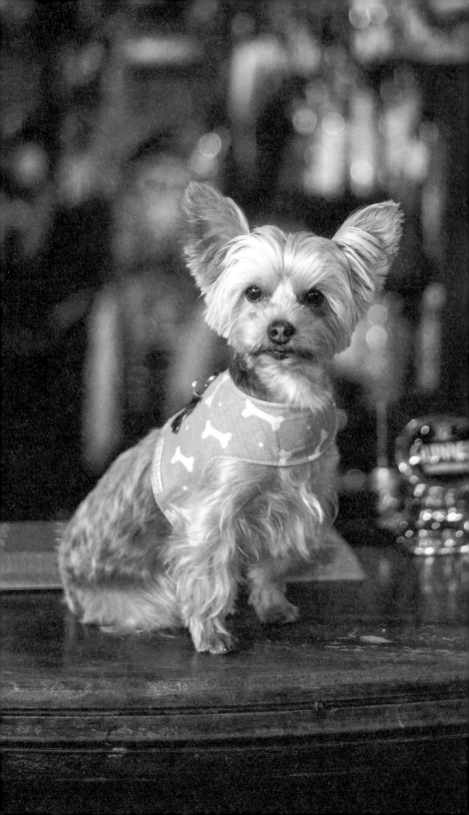

CHICHI

Yorkie

THE CHURCHILL ARMS

Where do they sleep
In my bed, of course, all around the
house – & cosy pubs

Favourite things
City walks, travelling on buses,
trains & underground – travelling
basically. Going to shops with cool
music, & relaxing in pubs

Most dislikes
Scooters & skateboards – sorry

Favourite place
Anywhere there are lovely people

Favourite drink
Starbucks soy milk babyccino

When not in pub likes to
Spend time in Kensington Gardens,
saying hello to people, & in
summer joining them on picnics

Likes cats or loathes cats
Indifferent

Best trick
Showing her belly ready for a tickle

Favourite toy
Mungo from Mungo & Maud

Favourite treat
Ruby Rufus cashmere jumpers,
& to eat, homecooked meals

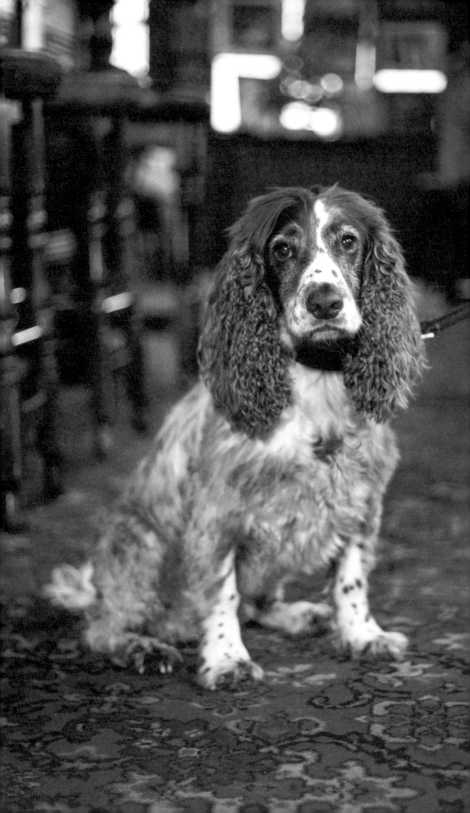

VIRGIL

Cocker Spaniel

THE CHURCHILL ARMS

Where do they sleep
Dog basket

Favourite things
Attention, car driving,
swimming

Most dislikes
Being ignored

Favourite place
The Churchill Arms

Favourite drink
Water

When not in pub likes to
Walks in Hyde Park, his garden
in Provence

Likes cats or loathes cats
Dominated by our cat

Best trick
Pretending strangers are his
new best friend

Favourite toy
Rubber cheese

Favourite treat
Food treats

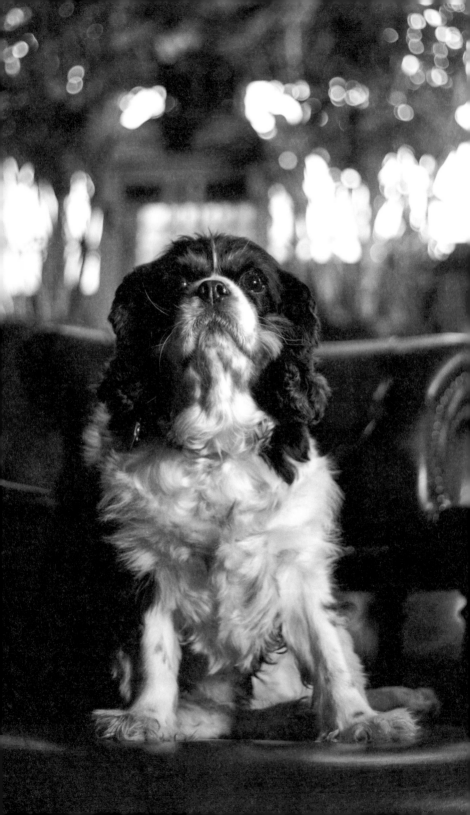

COCO

THE CHURCHILL ARMS

Cavalier King Charles Spaniel

Where do they sleep
Dog Basket

Favourite things
Fluffy toys

Most dislikes
Birds

Favourite place
Kensington Gardens

Favourite drink
Water

When not in pub likes to
Go on long walks

Likes cats or loathes cats
Loathes

Best trick
None

Favourite toy
Fluffy mouse

Favourite treat
Biscuits

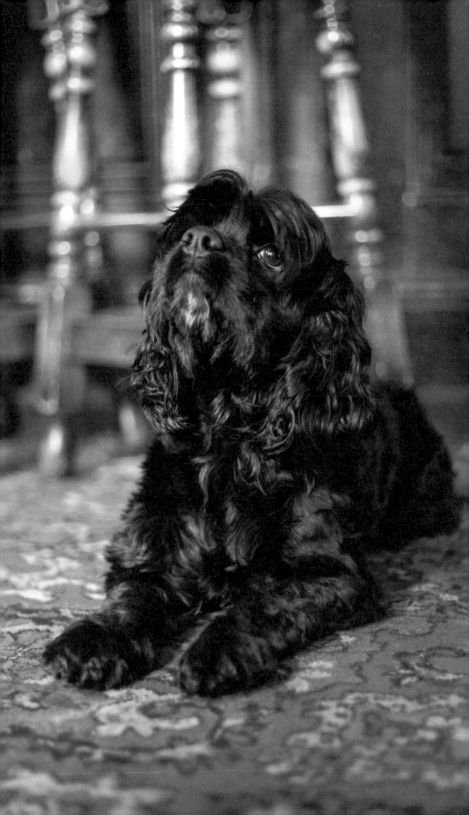

TOSCA

THE CHURCHILL ARMS

American Cocker Spaniel

Where do they sleep
Workshop

Favourite things
Being with me

Most dislikes
Broomsticks

Favourite place
Car

Favourite drink
Water

When not in pub likes to
Drink my wine

Likes cats or loathes cats
Nope!!!

Best trick
Refuse to give the ball back

Favourite toy
Grey mouse

Favourite treat
Chicken bones

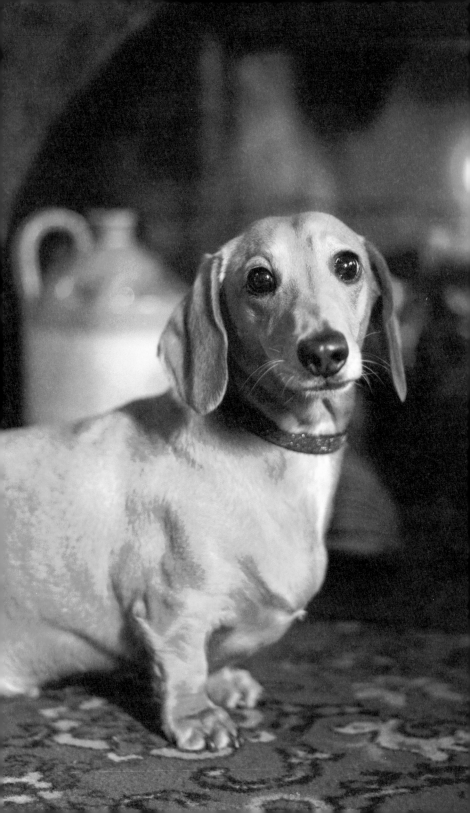

BORIS

THE CHURCHILL ARMS

Dachshund

Where do they sleep
Dog basket

Favourite things
Chews

Most dislikes
Rain

Favourite place
Battersea Park

Favourite drink
Water

When not in pub likes to
Visit family

Likes cats or loathes cats
Both – depends on the cat

Favourite toy
Ball

Favourite treat
Chews

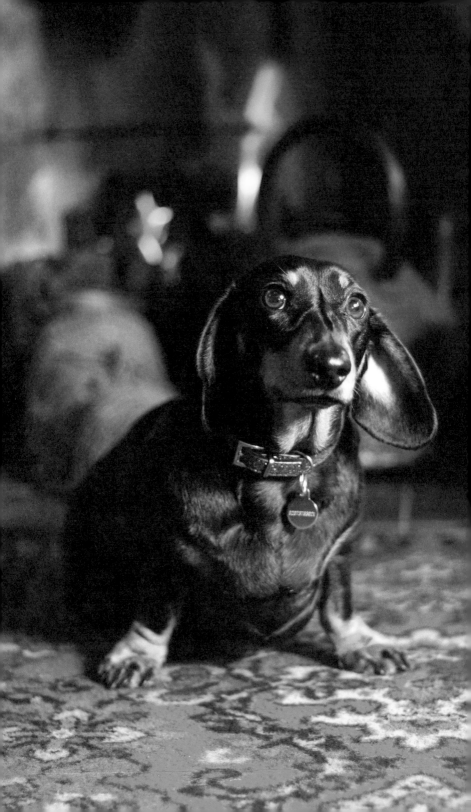

FRITZ

Dachshund

THE CHURCHILL ARMS

Where do they sleep
Dog basket

Favourite things
Chews

Most dislikes
Rain

Favourite place
Battersea Park

When not in pub likes to
Visit family

Likes cats or loathes cats
Indifferent

Best trick
None

Favourite toy
Ball

Favourite treat
Chews

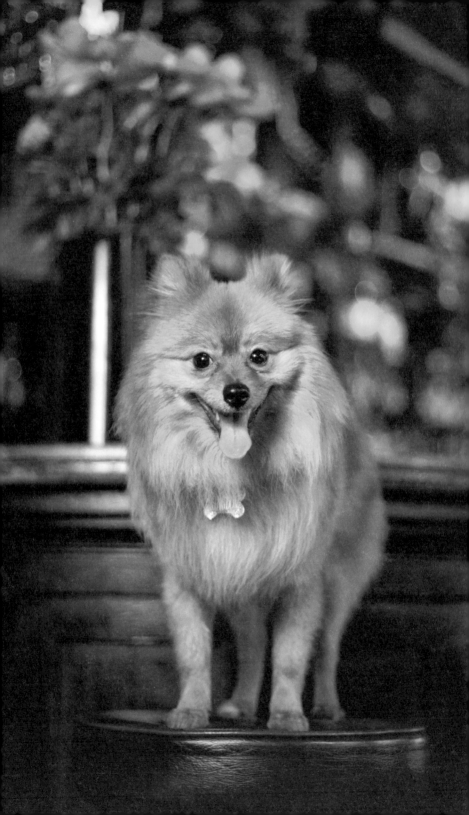

KINGDOM

THE CHURCHILL ARMS

Pomeranian

Where do they sleep
Next to my bed

Favourite things
Mickey Mouse, my tights, shows &
food, especially Casear salad
& vanilla ice cream

Most dislikes
NOTHING!!! He loves everything

Favourite place
Churchill Arms & of course
Hyde Park

Favourite drink
Water

When not in pub likes to
Play, sleep, eat, be friendly
to everybody

Likes cats or loathes cats
Not too sure

Best trick
Standing on his back legs
& begging.

Favourite toy
Mickey Mouse

Favourite treat
Steak, dried chicken & ice cream

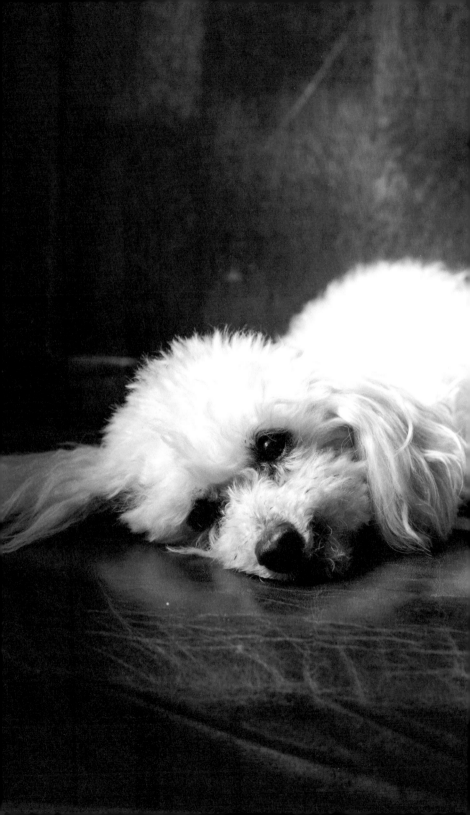

SAGE

WINDSOR CASTLE (KENSINGTON)

Toy Poodle

Sage's Space

Sage is my name.
Sage by name,
sage by nature.

My best friend was Lev
but he's gone.
He was here one day,
and not the next.

He's gone to a different place.
There's a dog-shaped space
where he used to be.

I hope I'll go there
too, someday. Wherever
it is. Whatever it is.

It's not the same
travelling from line
to line on the tube,
playing tug of war
by myself.

High Ones are okay,
but they can't bark.
They can't sit
in a sunbeam with me.

They haven't the time
to spare.

I like it
when no one knows I'm there.
When I vanish
into the walls,
hide in a bag beneath the table.

They need to think
that they're the only ones
who can feel.
The only ones entitled to grieve.

Just look at me,
and I'll prove
it's not true.

SAGE

Where do they sleep
Bed

Favourite things
Deceased partner dog (Lev),
sneaking into places, travelling
internationally, car & plane
journeys as well as train
& tube

Most dislikes
Swimming, walking (as he
has got older)

Favourite place
Next to me, (& Lev previously)
sitting in a sunbeam, watching TV,
sunbathing, people watching, on
the road

Favourite drink
Water on the rocks, coconut oil

When not in pub likes to
Hide in a bag under the table in
restaurant, attend lectures, go to
movies, comfort humans, be the
best roommate

Likes cats or loathes cats
Cats are a bit afraid of him
– he's smaller than them!

Best trick
To blend into surroundings so
no one sees him, therapy dog,
charming everyone with his
cuteness & intelligence, studio
assistant (painting)

Favourite toy
Yellow duck was Lev's favourite toy
(& they used to play tug of war)

Favourite treat
Chicken

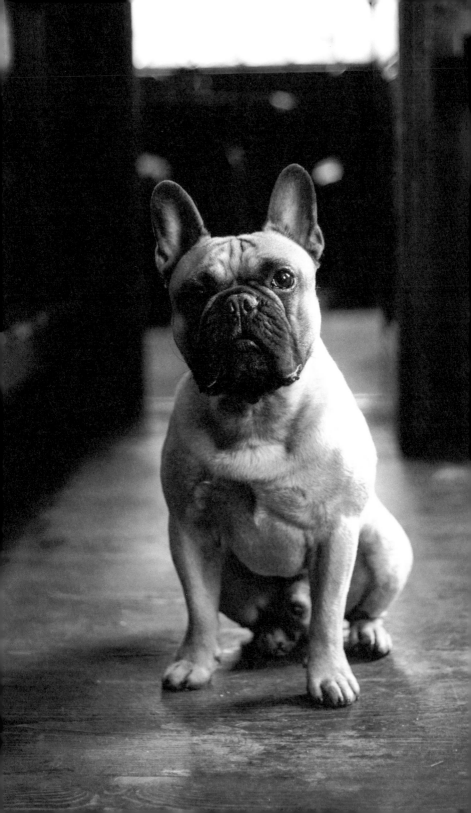

VIRGIL

French Bulldog

THE WINDSOR CASTLE (KENSINGTON)

Where do they sleep
In my bed

Favourite things
Chuckit, cheese, cuddling & laying out flat on belly in mud puddles

Most dislikes
Being bathed after he has been rolling in fox poo

Favourite place
Any sunny spot

Favourite drink
Ice

When not in pub likes to
Go paddling in the Serpentine

Likes cats or loathes cats
Loathes

Best trick
Being handsome & getting his owners free drinks

Favourite toy
His chuckit

Favourite treat
He does love a prawn shell

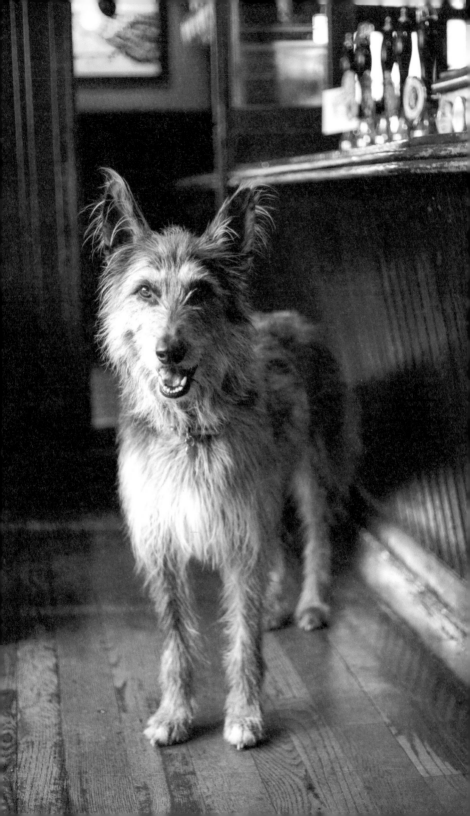

WILLIAM

Lurcher x German Shepherd

THE WINDSOR CASTLE (KENSINGTON)

Where do they sleep
In my room – on or off the bed
depending on how hot it is

Favourite things
Ice cream, joining in other dogs
ball games, CHICKEN, swimming
for sticks, running with a really fast
dog, wrestling with other big dogs,
getting a massage

Most dislikes
Fireworks, being left behind, crisps

Favourite place
Battersea Park where he has lots
of friends, but Kensington is better
for squirrels

Favourite drink
Vanilla milkshake given half
a chance – gravy

When not in pub likes to
Generally hang out with me,
whatever I'm doing, or kipping on
the sofa at home knowing there
are people around

Likes cats or loathes cats
Lives with a cat who he's fond
of but a bit jealous of sometimes.
This fondness does not extend
to other cats

Best trick
If I can't see where he's been to
the loo in the park & I ask him to
show me he'll take me to the spot

Favourite toy
Doesn't have toys & loses his ball,
but very keen on stealing my hats,
scarves, etc.

Favourite treat
White bread sausage sandwich,
butter, no ketchup

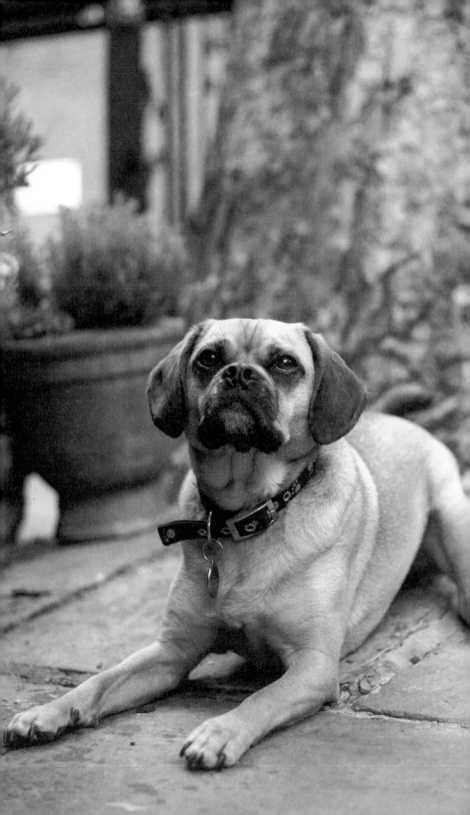

MONSTER

Puggle

THE WINDSOR CASTLE (KENSINGTON)

Where do they sleep
On the bed

Favourite things
Food, food, food (cucumber &
scrambled eggs), a belly rub but
only from Amanda

Most dislikes
Statues of animals & seeing
other animals on TV as he can't
understand why they won't play

Favourite place
The Churchill followed by Windsor
Castle, where he sniffs for any food
that may have fallen on the floor

Favourite drink
Gravy from roast dinner

When not in pub likes to
Go mad running through
Kensington Gardens, the cliffs
at Eastbourne or on the beach

Likes cats or loathes cats
Likes cats! He lives with 2 cats –
Murphy & Muppet. Muppet is his
best friend!

Best trick
High five & leave it

Favourite toy
Tennis ball

Favourite treat
Bits of chicken

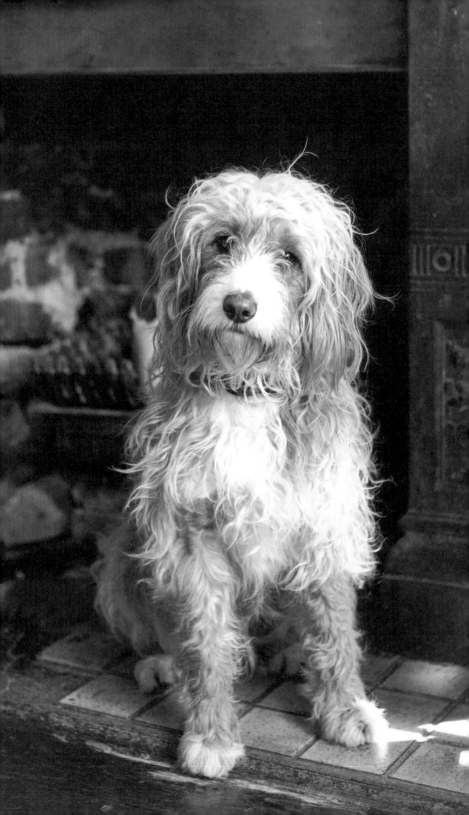

DOUGAL

THE LANSDOWNE

Cockapoo

Where do they sleep
My bed mostly

Favourite things
Tennis balls, stones being thrown, me, Hampstead Heath, swimming in the ponds

Most dislikes
Going to the vet

Favourite place
Me or my twin sister's lap

Favourite drink
Licks condensation off pints

When not in pub likes to
Run & chase balls, have his tummy tickled

Likes cats or loathes cats
Ambivalent

Best trick
Running jump to catch ball – has been applauded by strangers in the park

Favourite toy
Lamb

Favourite treat
Marrow bones or pig's ear at the Bull & Last pub

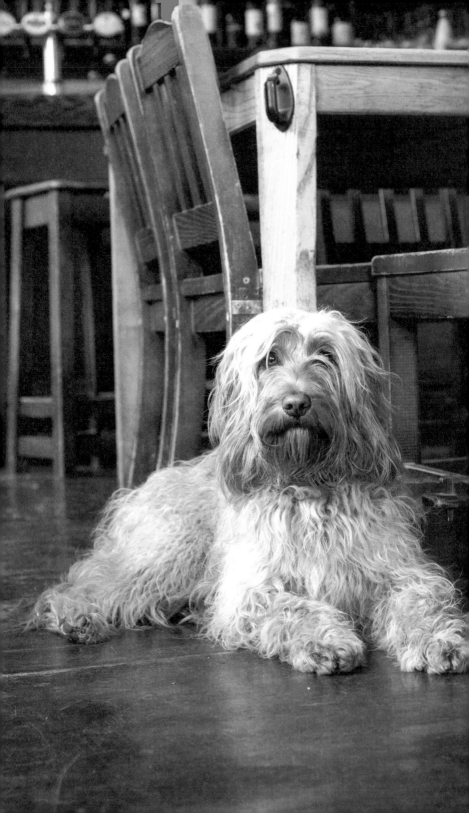

DAISY

THE LANSDOWNE

Cockapoo

Where do they sleep
Her bed or my bed

Favourite things
My son's underpants

Most dislikes
Foxes

Favourite place
Hampstead Heath

Favourite drink
Guinness

When not in pub likes to
Chase squirrels, run in Hampstead Heath, roll in fox poo

Likes cats or loathes cats
Likes my cat nutmeg

Best trick
High five & roll over

Favourite toy
Pants

Favourite treat
Marrow bones at the pub

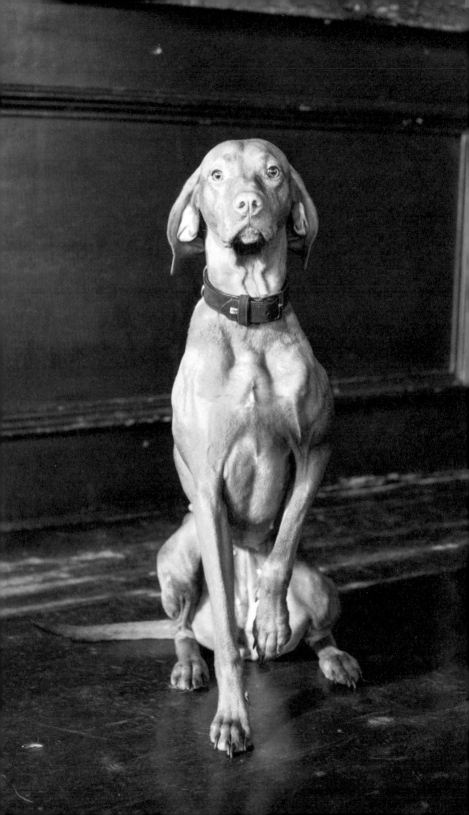

TIA

THE LANSDOWNE

Hungarian Vizsla

Where do they sleep
In bed with us

When not in pub likes to
Be in the park

Favourite things
Chasing other dogs

Likes cats or loathes cats
Likes everyone

Most dislikes
Rain

Best trick
Teaching us how to behave

Favourite place
Sunniest spot in the house

Favourite toy
Us

Favourite drink
Hungarian Palinka

Favourite treat
Our food

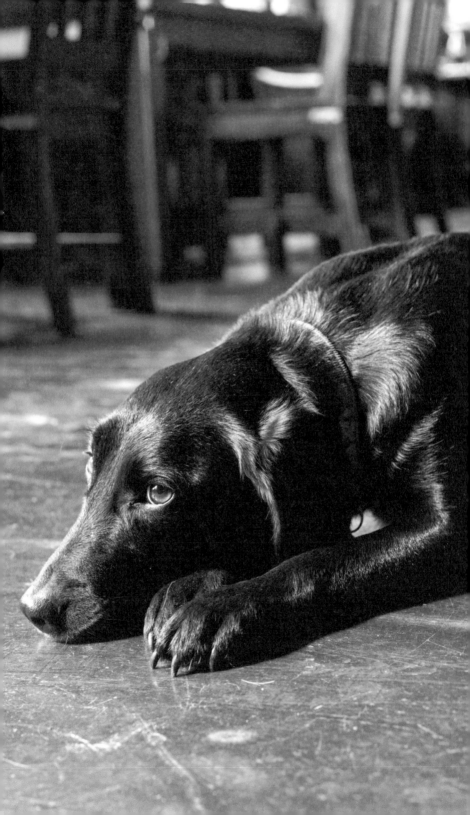

ANNA

THE LANSDOWNE

Sprollie (Springer Spaniel x Border Collie)

Where do they sleep
The office sofa
(but see "Favourite treat" below)

Favourite things
Full social programme: business
meetings, coffee, lunch, tea,
walking & swimming

Most dislikes
Paper bags & balloons
(very scary)

Favourite place
The Lansdowne

Favourite drink
Confirmed teetotaller (water only)

Likes cats or loathes cats
Ignores cats

Best trick
Picking up mown grass with
her mouth

Favourite toy
Ball (but doesn't own one)

Favourite treat
Lying with her head high on a
pillow in the middle of our bed

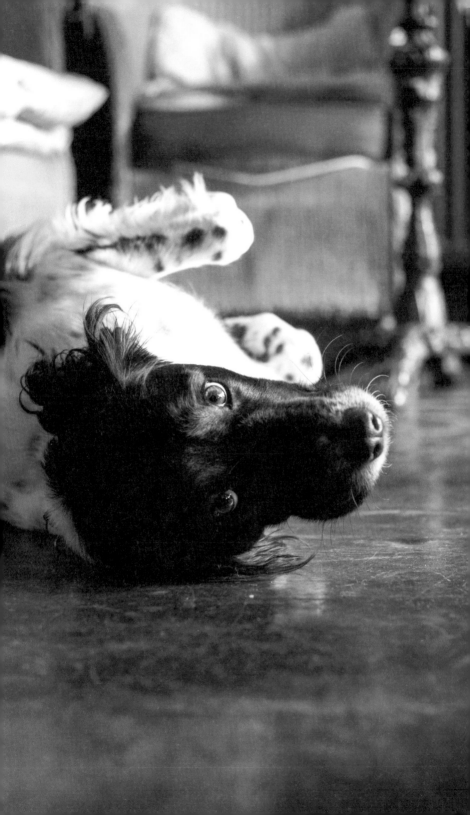

CONOR

THE LANSDOWNE

Sprollie (Springer Spaniel x Border Collie)

Where do they sleep
The office sofa

Favourite things
Full social programme: business meetings, coffee, lunch, tea, walking & swimming

Most dislikes
Improper behaviour (has very high moral standards)

Favourite place
The Lansdowne

Favourite drink
Confirmed teetotaller (water only)

When not in pub likes to
Go on very long walks. Currently walking the South West Coastal Path

Likes cats or loathes cats
Chases cats but never catches them

Best trick
Posing for professional photographs

Favourite toy
Ball (but doesn't own one)

Favourite treat
Having his tummy tickled at length

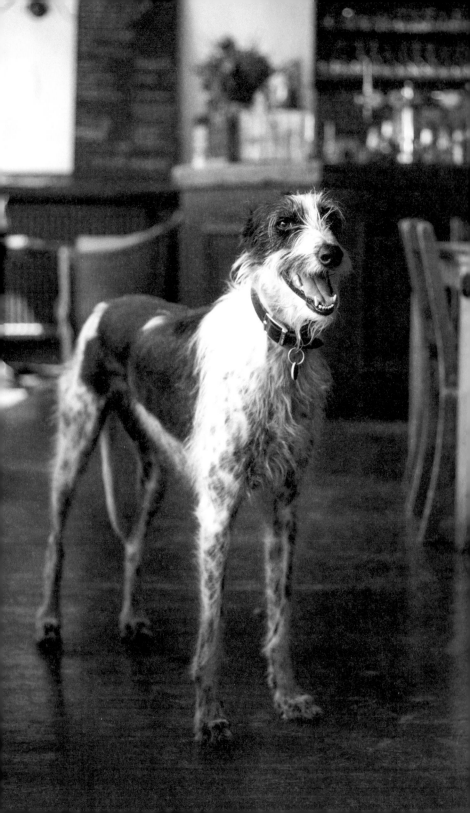

DOBBY

THE LANSDOWNE

Lurcher

Where do they sleep
Downstairs on her bed (very comfy, by the radiator)

Favourite things
Running & chasing

Favourite place
The sofa

Favourite drink
Puddles

When not in pub likes to
Run & chase, sleep

Likes cats or loathes cats
Likes – has a cat friend called Spit

Best trick
Doesn't do tricks, far too cool for that

Favourite toy
The Parson, a squeaky canvas chicken

Favourite treat
Raw beef

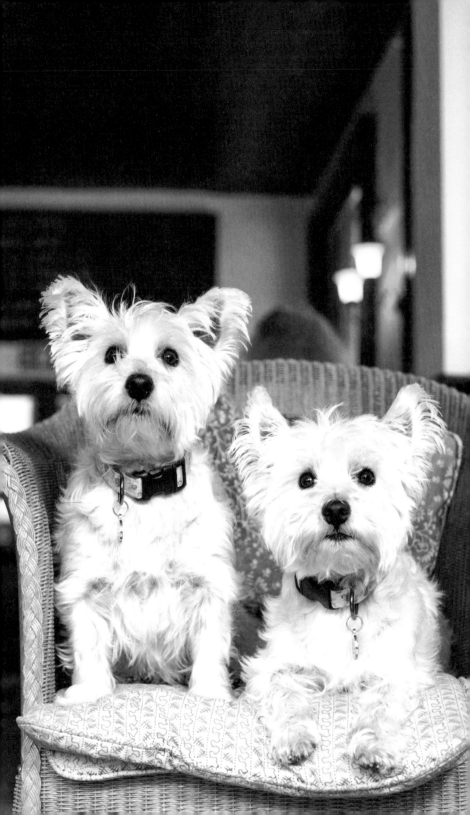

BEA & BUMBLE

THE LANSDOWNE

Westie

Bea and Bumble's Army

We're Westies in London!
An invasion uv cute
wi our wee tartan coats
an our wee tartan beds.

Dyin ti splash
in Trafalgar Square,
pish on thi sacred Wembley turf,
shag thi goal posts,
swing on thi crossbar.

Flaunt our Scottish banknotes
in shops.

Live in thi past.
Thi distant glories.
Legends we've heard
since we wur pups.

Jim Baxter playing
keepie-up.

William Wallace.
John Logie Baird.
Jimmy Krankie.
Frankie Boyle.

The saxophone solo
on Baker Street.

We might seem ti be
a wee bit small
but that's nae reason
ti forget who we ur.

Total bampots,
an proud uv it.

Bonny Prince Charlie!
(adopted Italian)
Nicola Sturgeon!
Tony Blair!

Sorry fur that,
we aw make mistakes.

Clock thi time, we huvti run.
We're off ti batter
thi Battersea dugs.

Square Go! Ya Beauty!

BEA &
BUMBLE

Where do they sleep
Snuggled with mummy & daddy

Favourite things
Licking faces, rolling in fox poo,
staring into space contemplating
the meaning of life, watching bugs,
snuggles, playing chase

Most dislikes
Squirrels, animals on TV, loud
noises, foxes in the garden

Favourite place
Duntisbourne Abbots, Cotswolds

Favourite drink
Gin & tonic, pint of stout

When not in pub likes to
Chase squirrels & pigeons,
run in the park, meet new people

Likes cats or loathes cats
Loathes cats

Best trick
Greeting people standing on
their back legs (like a meerkat) &
looking adorably cute all the time

Favourite toy
At the moment their Mungo
& Maud camel, stuffed rat or
stuffingless polar bear

Favourite treat
Any type of food – not fussy

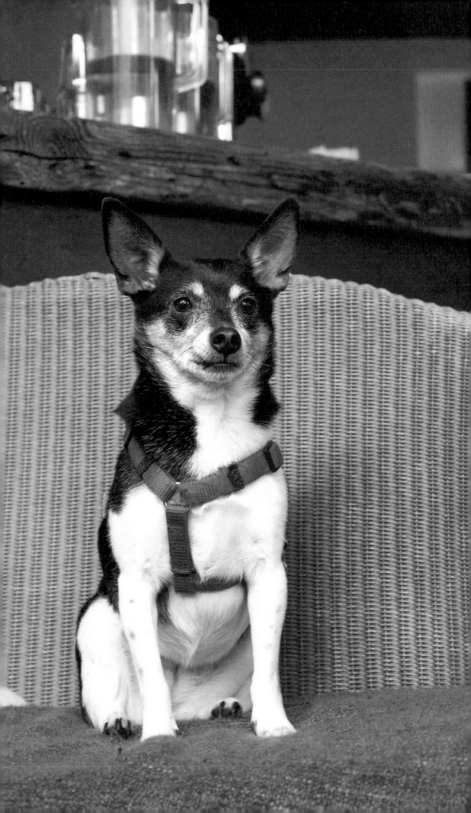

KALI

THE LANSDOWNE

Rat Terrier x Chihuahua

Where do they sleep
In her own bed, next to mine

Favourite things
Small tennis balls

Most dislikes
Baths

Favourite place
Hampstead Heath for a good walk

Favourite drink
Water

When not in pub likes to
Play fetch

Likes cats or loathes cats
Likes cats, but cats loathe her!

Best trick
None! Only knows sit,
stay & down

Favourite toy
Christmas pudding squeaky toy

Favourite treat
Lily's treats

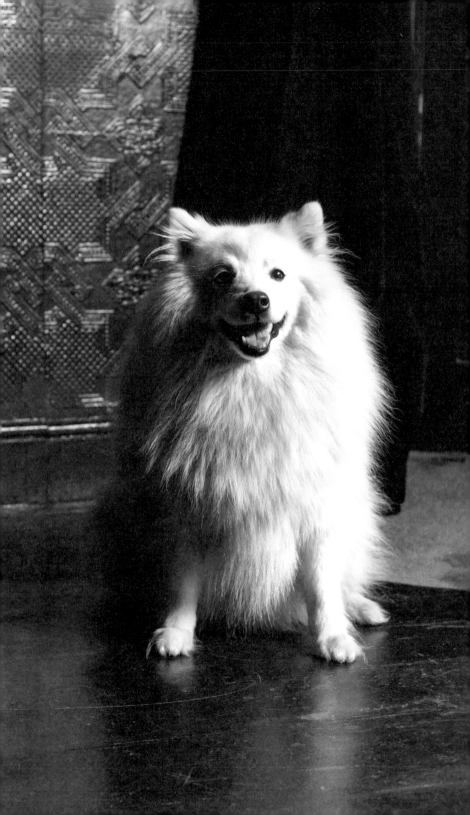

PARIS

Japanese Spitz

THE LANSDOWNE

Where do they sleep
In the bed or on the floor on
a big cushion

Favourite things
Food – cheese, chicken & duck

Most dislikes
Squirrels, rabbits

Favourite place
Primrose Hill

Favourite drink
M & S vanilla bean thick milkshake

When not in pub likes to
Walk

Likes cats or loathes cats
Likes

Best trick
Getting attention, looking lost

Favourite toy
Soft toy Husky

Favourite treat
Raw carrots whole, chewy bones

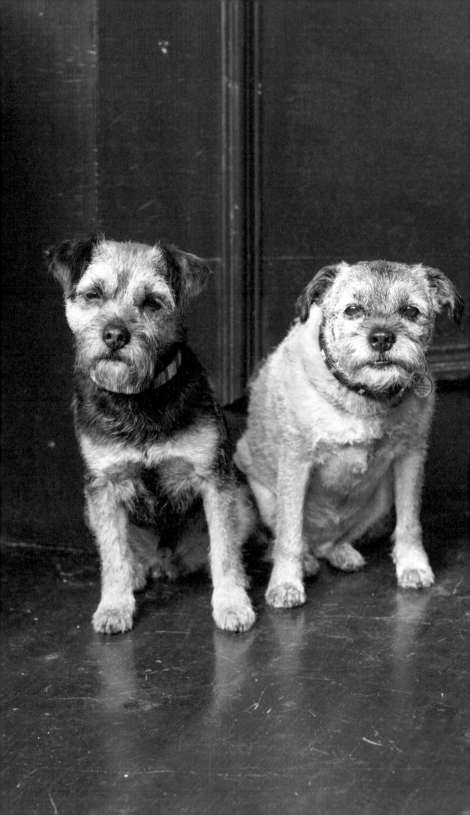

MOLLY & GEORGE

THE LANSDOWNE

Border Terrier

Where do they sleep
In our bedroom

Favourite things
Treats, Barbie ball, Mum & Dad

Most dislikes
Spaniels, rain, pizza scooters

Favourite place
Primrose Hill, Dartmouth

Favourite drink
Camden lager

When not in pub likes to
Think about going to pub, chasing squirrels

Likes cats or loathes cats
Loathes

Best trick
Doing what they're told – LOL

Favourite toy
Pepperami, rag doll

Favourite treat
Meat

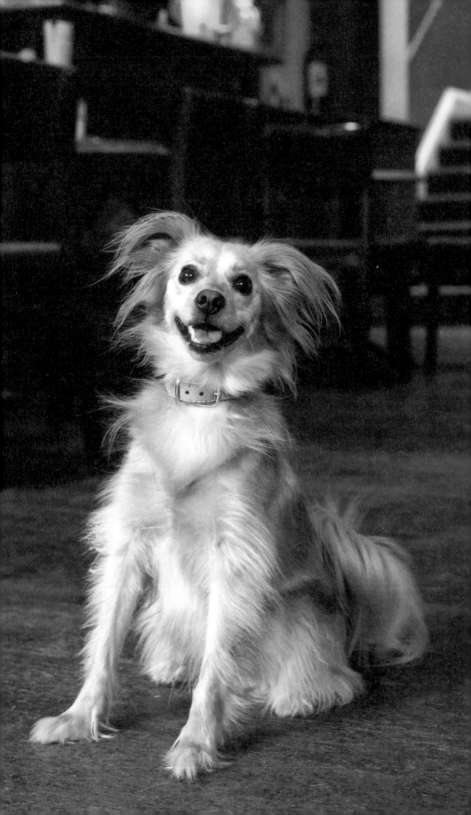

SOPHIE

THE WINDSOR CASTLE (REGENT'S PARK)

Chihuahua x Golden Retriever

Sophie's Voice

I'm awesome! I'm mental!
I'm beautifully special

with my ears and my legs,
my hairdo, my smile.

I'm half Chihuahua
and half Retriever,
but I don't know who's
the giver, the receiver.

I guess the Mexican
was my dad. He must have stood
on a bucket to reach.

Go on little chap!
That's how it's done!

Or maybe I'm just
a Chihuahua myself
balancing on
a Retriever's shoulders.

Fooling you all
for donkey's years.

A double act
in the Music Hall,
or sitting in The Double Dip pub
conducting a medley
of Cockney songs.

Blitz-time tunes
about keeping
your knees up,
not dilly-dallying, rolling barrels.
Slanging about
the good old days.
Ronnie and Reg, Jack the Hat,
Jack the Ripper, Artful Dodgers.

Phil Mitchell. Elephant Men.
Apples and pears. Plates of meat.

I'm part of
an old and proud tradition.
Loveable wackos
strutting our stuff.

To survive in this world
you have to be tough.

SOPHIE

Where do they sleep
In bed with the owner

Favourite things
Socks, different toys, birds

Most dislikes
Garbage bags, loud noises

Favourite place
Regent's Park (Loves the birds, ducks, etc.)

Favourite drink
Water

When not in pub likes to
Chase ducks around the park

Likes cats or loathes cats
Scared of cats

Best trick
High five

Favourite toy
People's socks

Favourite treat
Bones

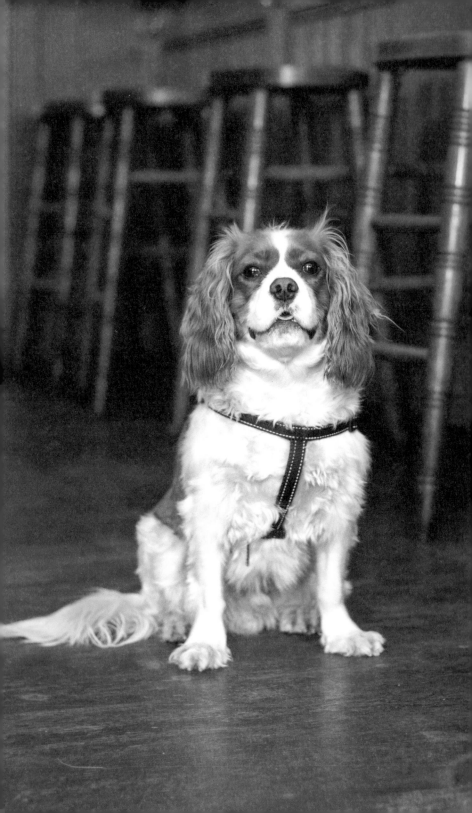

HARVEY

THE WINDSOR CASTLE (REGENT'S PARK)

Spaniel

Where do they sleep
My bed

When not in pub likes to
Go to the park

Favourite things
His football

Likes cats or loathes cats
Likes

Most dislikes
Staying alone

Favourite toy
His football

Favourite place
Regent's Park

Favourite treat
Bone

Favourite drink
Water

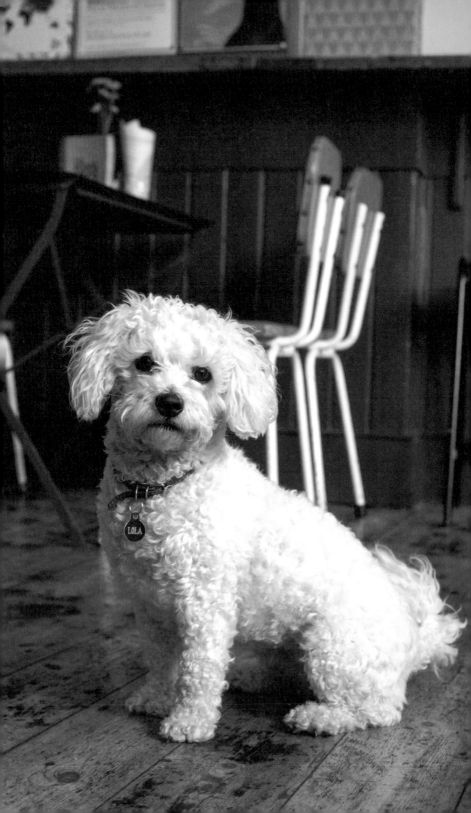

LOLA

THE KING & CO

Zuchon (Bichon x Shih Tzu)

Where do they sleep
Under the bed, often found on
the bed in the morning

Favourite things
Tummy rubs, running, being
with owners

Most dislikes
Squirrels, being on her own for
even a few minutes

Favourite place
The pub & anywhere near people

Favourite drink
Favours traditional British Brown
Ales instead of the new American
style craft beers!

When not in pub likes to
Chase squirrels

Likes cats or loathes cats
Wants to be friends with cats but
they often feel differently

Best trick
Chasing her own tail, catching
it in her mouth, then carrying it
across the room!

Favourite toy
Anything with a squeak

Favourite treat
Stuffed bones

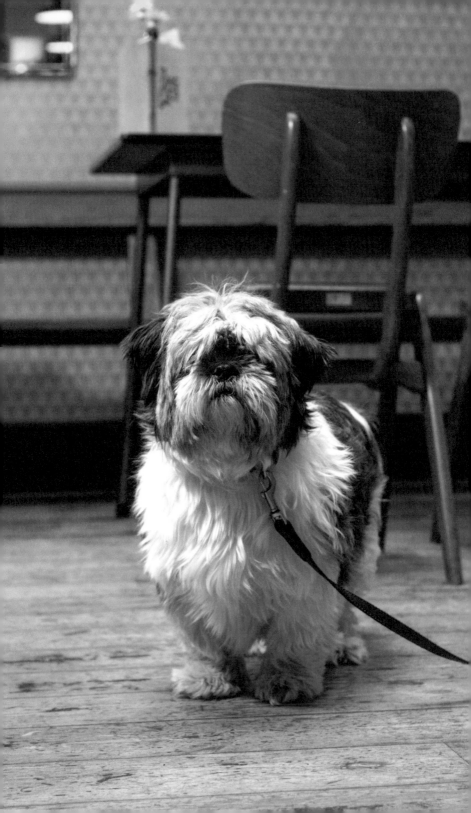

GIZMO

THE KING & CO

Shih Tzu

Where do they sleep
In his bed in my bedroom

Favourite things
Walks

Most dislikes
Baths

Favourite place
The living room

Favourite drink
Water

When not in pub likes to
Be in the park

Likes cats or loathes cats
Likes cats

Best trick
Going down the slide in
the playground

Favourite toy
Ball & teddy

Favourite treat
Sausages

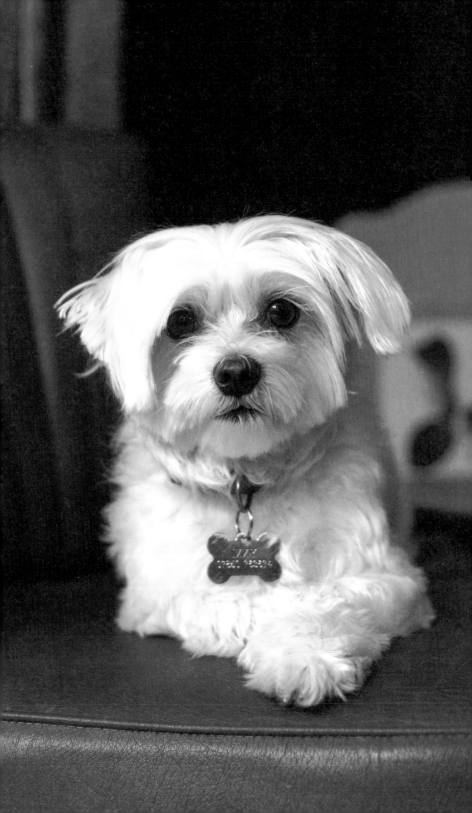

IZZY

THE KING & CO

Maltese

Where do they sleep
Dirty laundry basket

Likes cats or loathes cats
Indifferent

Favourite things
Squeaky toy named Dino, hide &
seek, love & cuddles, showers

Best trick
She's great at "hunting" the hidden
treats... & foraging mushrooms

Most dislikes
Not much: she's very easygoing.
Cameras, I guess?

Favourite toy
Plush toys, squeaky toys

Favourite place
People's laps & arms

Favourite treat
She loves rawhide

When not in pub likes to
Go on muddy walks & hikes – she's
a pro hiker & has done the Lake &
Peat Districts

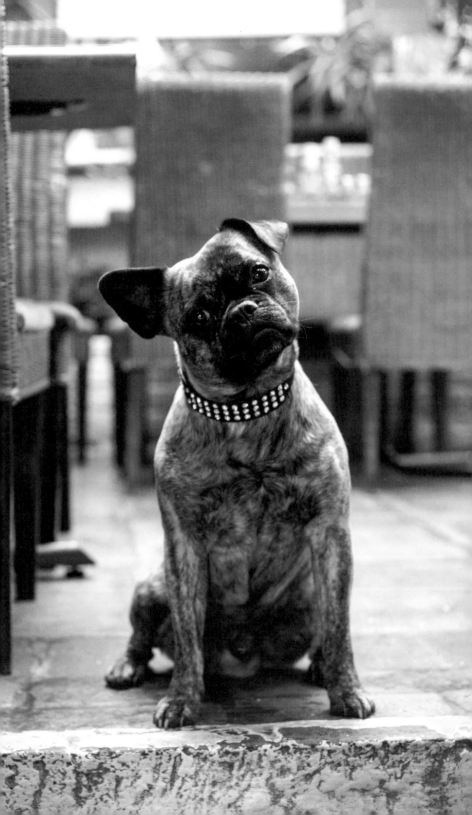

RED

PORTOBELLO GOLD

French Bulldog x Pug

Where do they sleep
In my bed

When not in pub likes to
Walk in park & sleep

Favourite things
Water bottles, chicken

Likes cats or loathes cats
Loathes

Most dislikes
Dogs on TV

Best trick
Sit & paw

Favourite place
Hyde Park

Favourite toy
Ball

Favourite drink
Guinness

Favourite treat
Cheese

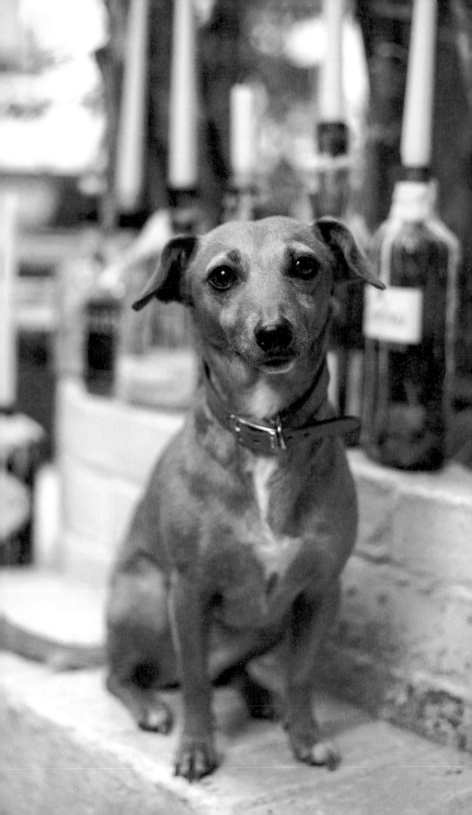

MISS JONES

Heinz 57

PORTOBELLO GOLD

Where do they sleep
Under the duvet, given half a
chance on a velvet cushion if
available, if not cashmere will do

Favourite things
Balls, balls, balls, cuddles, balls,
tug of war, balls & cuddles. Oh
& old chicken bones

Most dislikes
The rain

Favourite place
A comfy lap

Favourite drink
Cheeky Guinness

When not in pub likes to
Chase balls & have cuddles

Likes cats or loathes cats
Depends on how charming
the cat is

Best trick
Jumping

Favourite toy
Squeaky burger unfortunately

Favourite treat
Typical girl – chocolate or cheese
of course

PUBS

Rosemary Branch
2 Shepperton Road
London
N1 3DT

The Red Lion & Sun
22 North Road
Highgate
N6 4BE

The Rosendale
65 Rosendale Road
West Dulwich
London
SE21 8EZ

The Prince Regent
69 Dulwich Road
London
SE24 0NJ

Elm Park Tavern
76 Elm Park
London
SW2 2UB

The Merchant
23–25 Battersea Rise
Clapham Junction
SW11 1HG

No. 32 The Old Town
32 The Pavement
London
SW4 0JE

The King & Co
100 Clapham Park Road
London
SW4 7BZ

The Queen's
46 Regents Park Road
Primrose Hill
London
NW1 8XD

The Lansdowne
90 Gloucester Avenue
London
NW1 8HX

The Windsor Castle
98 Park Road
Regent's Park
London
NW1 4SH

The Bull & Last
168 Highgate Road
London
NW5 1QS

The Spaniards Inn
Spaniards Road
Hampstead
London
NW3 7JJ

The Champion
1 Wellington Terrace
London
W2 4LW

The Churchill Arms
119 Kensington Church Street
London
W8 7LN

The Windsor Castle
114 Campden Hill Road
Kensington
London
W8 7AR

Portobello Gold
95–97 Portobello Road
London
W11 2QB